To Jen
All our Love
Marianne et Laurent
xxx xxx.
Christmas 2007.

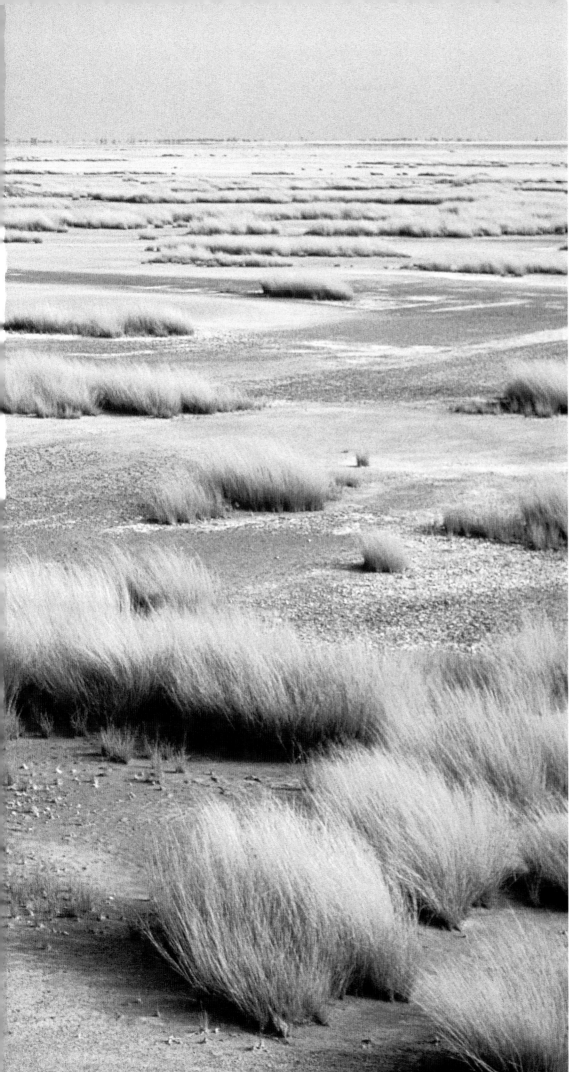

Kalahari desert, Botswana

VANISHING FOOTPRINTS

*F*or we, the /Xam people,
each of us owns a wind;
each one has a cloud
that comes out when we die.
Therefore the wind
when we die,
the wind blows dust
covering the tracks,
the footprints we made
when walking about living...

Dia!kwain, /Xam (Cape Bushman/San), South Africa

ABOUT THE AUTHORS

Anthony Swift is a widely traveled writer and journalist who reports on the experiences of marginalized people. He worked as an investigative reporter in South Africa under apartheid and is the author of *Children for Social Change* and *Working Children get Organized*, among other books on social issues. He has a particular interest in emerging movements of organized street and working children.

Ann Perry was born in South Africa and trained as a social anthropologist. She now works as a counselor and as an adult educator, teaching communications and study skills. She and Anthony live and work in Oxford, England.

ACKNOWLEDGEMENTS

In writing *Vanishing Footprints*, the authors realised that but for a very small number of people from the settled world who have lived with nomadic people and learned about their lives little would be known of them. The opportunity to learn from what they have to tell us would have been lost. So we have them to thank.

Among those who helped us directly to gain some insight into people who live on the move were Dawn Chatty, Chair of the Commission of Nomadic Peoples, Laura Rival, Paul Baxter, Mark Nuttall and Survival International.

Nomadic people speak

VANISHING FOOTPRINTS

BY ANTHONY SWIFT AND ANN PERRY

Published by New Internationalist Publications Ltd
Registered office: 55 Rectory Road, Oxford OX4 1BW, UK.
www.newint.org

Reprinted 2002

Design by Barbara Willi, Zürich, Switzerland
Editor: Troth Wells, New Internationalist Publications,
Oxford

Printed by Snoeck-Ducaju & Zoon N. V., Belgium

British Library Cataloguing-in-Publication Data.
A catalogue record for this book is available from the
British Library.

■ CONTENTS

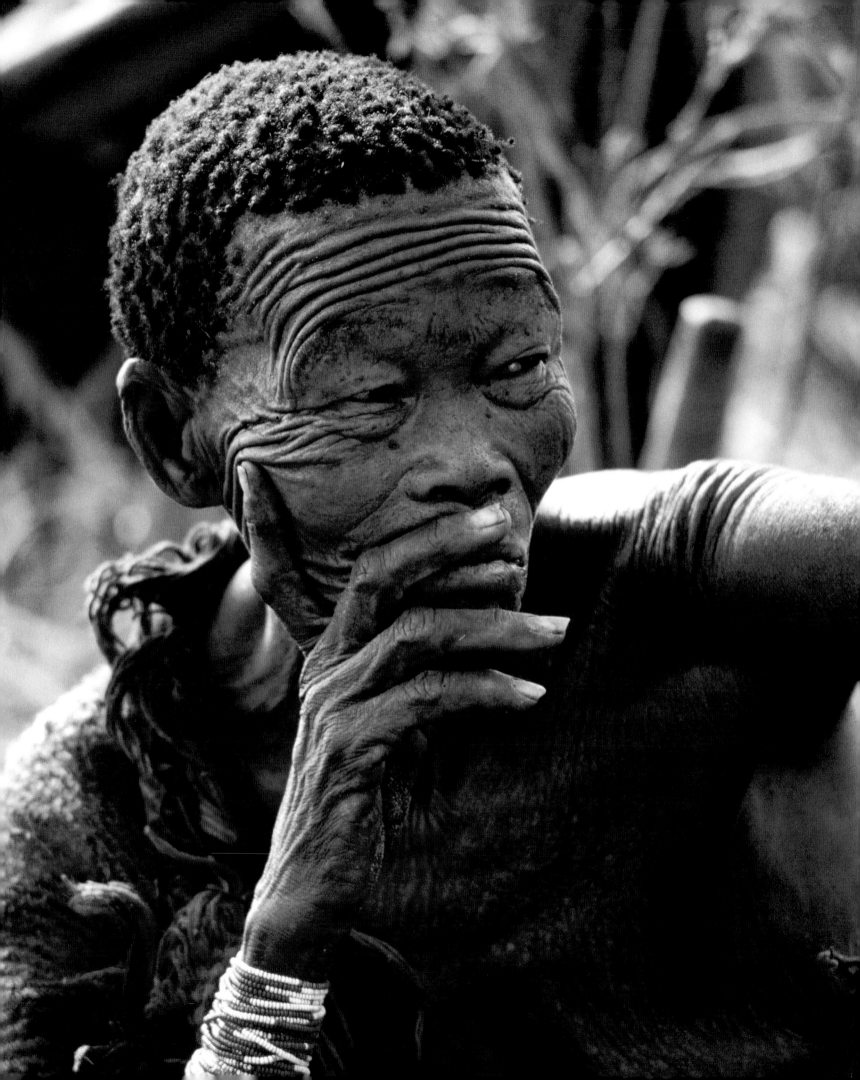

INTRODUCTION

Knowledge was passed down by word of mouth – poetry or folktales – or by our parents teaching us the skills we needed... how to weave from dried grass; my father taught me how to care for our animals.

We didn't spend much time talking about the past... Everything was today, what are we going to do today? How are we going to eat? Where can we find water? *

Waris Dirie, Somali, East Africa

▌ Given that thousands of generations of our ancestors were hunters and gatherers on the move, it may well be that this way of life is an indelible part of what makes us human. ▌

Richard Leakey, The Making of Mankind

Nomadic people share the globe but live in a very different world to settled people, the builders of permanent homes, cities and states, creators of the global market place. They live in environments where non-nomads would very quickly die: semi-deserts, forest and arctic icescapes. Nomads survive by taking what they can from the environment – either hunting and gathering or grazing herds of cattle, camels, reindeer, sheep and goats.

The industrialized world has existed a trifling 250 years. Agriculture, the keystone for a settled way of life, has been practiced for 10,000 years. In the million years of human existence the great majority of people developed ways of living on the move from what nature provides.

As the industrialized world has expanded, the space for nomads has rapidly contracted. It continues to do so. They exist on the periphery of what some call the 'real' world and at the edge of settled people's awareness. Settled people are often fascinated with the idea of nomadism. It appears attractive perhaps because life on the move represents an historical choice quite opposite to a settled existence. It can seem more deeply rooted in human experience and at the same time more in touch with nature. Nomadic people have no recorded history and live strongly in the present. They rely on oral tradition to define and redefine their world.

Some ancient rock paintings aside, they have left little mark on this world. Their footprints are soon lost to wind and rain. In fact we would know little about the nomads of the world's hard places were it not for a handful of individuals – writers, anthropologists, travelers and film makers – who have lived with them, struggled with their environments, learned their languages and got to know them. It is

from their rich writings and personal communications and the reported voices of nomadic people themselves, conveyed mainly through myths, stories, prayers and songs, that we have tried to capture something of the nomadic way of life. Sometimes we hear from nomadic people at first hand, from gifted storytellers like Nisa, an elderly San woman from southern Africa:

Fix my voice on the machine so that my words come out clear. I am an old woman who has experienced many things and I have much to talk about. *

Nisa, !Kung San, southern Africa

This account is about people whose way of life is rapidly changing. Many of them no longer lead their lives as we describe them. Listen to what nomads have said about their traditional way of life, which shows the rich contribution people who live on the move have made and continue to make in defining what it is to be human.

* *Quotes from nomadic people are in italics.*

We are fortunate, like a bird who has wings. We can fly to anywhere we please. If the place where we have built our houses becomes dirty, or muddy, or slippery, and not good anymore, we just move away. This is the way it has always been. When we are walking, and we feel like stopping, we might stay in one place for just one or two days, or three days. And if we want to move, we just move... We always move, and always look for a place that we like, a place where we can be happy... where there are many animals, where the sago [extract from the sago palm] is plentiful. And we look for a place where the river is near, and where the water is good, where it is easy to make good sago. That is why we are always moving.

Lejeng Kusin, Penan, Borneo

Nomadic people in harsh environments move partly because they have to. People who hunt and forage for plants and other food – such as Australia's Aboriginal people, the Inuit (Eskimos), Mbuti rainforest pygmies of the Congo, Amazonian Indians – move in quest of new supplies of wild vegetation, fruits, fish or animals to hunt. The herders of the highlands, open plains and semi-deserts – like the Gabra people of East Africa, Sahara Bedouin and Somali who keep camels – move their animals seasonally in search of scarce pasture and water.

As nomads we traveled constantly, never staying in one place for more than three or four weeks. This constant movement was driven by the need to care for our animals. We were seeking food and water to keep them alive, and in the dry Somalian climate these necessities were seldom easy to find.

Waris Dirie, Somali, East Africa

Some people adopted a life on the move because of conflict and fear of other groups. In South Africa, Bushmen (San) who recorded their religious ceremonies in rock art and some Amazonian Indian groups may both once have led more settled patterns of life.

But we know also that many people live on the move because they choose to do so. Nomadism supports a way of being in the world that is celebrated. Arduous as moving sometimes is, the Inuit for example look forward to a change of scene and of dwelling just as they look forward to each turning season:

▌ In the autumn the talk is about how good it will feel to move into an igloo from a tent. Even the process of moving is exciting. It sometimes seemed as though moving – rearranging the environment – was a pleasure in itself. Once it was done they enjoyed the freshness of a new home, a floor carpeted with reindeer moss and cranberry blossoms. ▌

Jean L Briggs, Never in Anger

Often, nomadic people move in small groups – traditionally on foot, dog-drawn sledge, horse, camel or boat – ways of traveling that keep them open to the environment and in close contact with each other.

Thomasie Nutariariaq, an Inuk from Igloolik, Canada

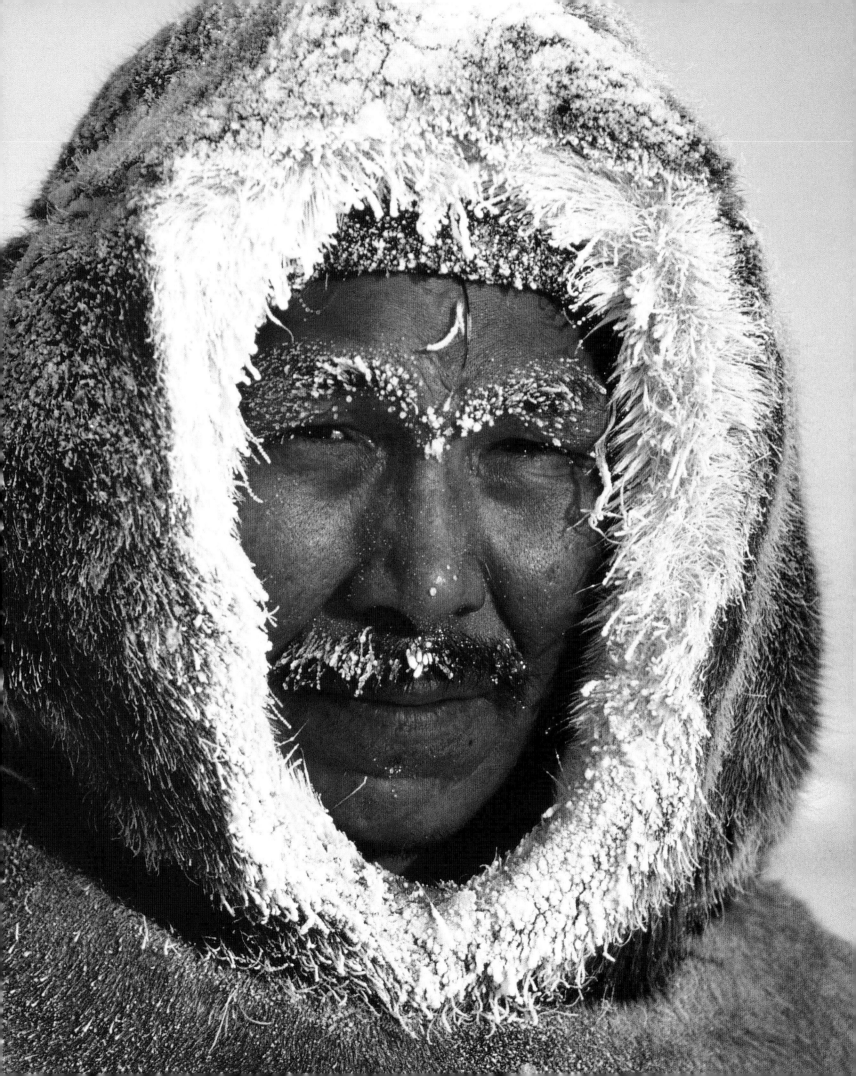

Several years ago writer Anthony Swift was taken to meet Turkana cattle-herders from Kenya on a cattle drive through semi-desert in Karamoja in northern Uganda:

❚ They had to negotiate the right to pass unhindered – not with border authorities but with the Karamojong. Animal herders like themselves and given as they are to coveting and raiding the cattle of others, the Karamojong believe they are the rightful owners of all the world's cattle.

The setting was empty scrubland, distinguished by a long low distant ridge, under a vast sky. The pale grays and beiges of animals gradually emerged and separated themselves from the tones of the surrounding veldt into a horizontal liquid mass. Close up, the animals though thin, looked noble, with dewlaps swaying at their throats, the upward sweep of horns, some as broad as a man's outstretched arms, the hair on their flanks shaved into fantastical patterns.

It had taken me a plane, hotels, a four-wheel drive, life insurance, medical and other gear and a guide to get to this wilderness. For the lone herd-boy who walked barefoot, with a cloth knotted over one shoulder and casually swinging a switch, all that space was home. At first it seemed he had it to himself. No sooner did we approach him, than women in beads and leather aprons and other children materialized to join us. Last to appear were warriors. They had been in hiding, watching us, guns at the ready. At that time Karamojong men were freshly armed with sophisticated weaponry they had seized from Ugandan strongman Idi Amin's abandoned armories and there was a drought so the situation was unusually tense. In fact the Turkana groups were in little danger of cattle raids just then. The Karamojong, I was told, would bide their time until the Turkanas' return journey. They would then raid cattle that would be better fed. ❚

On another continent, Quashqai nomads in southern Iran – famous for the Gabbeh rugs that their women weave and which poetically depict their landscape – get about on camel and horseback:

❚ The Quashqai men were lean, hard-mouthed, weather-beaten and wore cylindrical caps of white felt. The women were in all their finery: bright calico dresses bought especially for the springtime journey. Some rode horses and donkeys; some were on camels, along with the tents and tent poles. Their bodies ebbed and flowed to the pitching saddles. Their eyes were blinkered to the road ahead. A woman in saffron and green rode by on a black horse. Behind her, bundled up together on the saddle, a child was playing with a motherless lamb; copper pots were clanking, and there was a rooster tied on with a string.

She was also suckling a baby. Her breasts were festooned with necklaces, of gold coins and amulets. Like most nomad women, she wore her wealth. What, then, are a nomad baby's first impressions of this world? A swaying nipple and a shower of gold. ❚

Bruce Chatwin, The Songlines

Thousands of miles away in southeast Asia, Borneo's rainforest Penan people move in good-natured bands:

When we are moving, we walk slowly and take it easy. Whenever we want to sit and rest, we sit and rest. That is how we manage, when we are moving and carrying big loads. When our load feels too heavy, we put it down; when we feel rested and strong again, we walk on. If we are moving and are carrying heavy things on our backs, and we reach a river, if we feel hot, we go down to it and bathe. We all bathe, adults and children. We never have it very hard when we are traveling.

Lejeng Kusin, Penan, Borneo

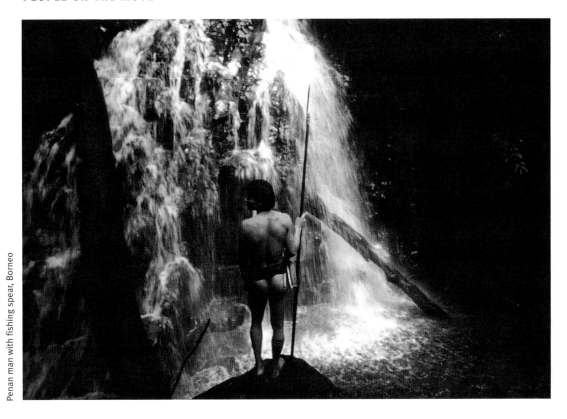

Penan man with fishing spear, Borneo

Among hunting and gathering groups, men and youths carry hunting weapons – traditionally, bows and arrows or spears or clubs or blowpipes – and machetes to clear the path. Women carry bundles of possessions and equipment. Even young children carry something – smaller items, such as cooking pots. The hunters may go on ahead in pursuit of game.

Meanwhile, beyond the Pacific in the Amazonian forest, Mekranoti groups experience a lifting of spirits when on trek:

▌ While the women were preparing the shelters and searching for stones to make ovens, the men departed for their daily hunting session. The camp was a very pleasant sight. The children were having a wonderful time. Whereas in the village the playground of the younger ones was restricted to the plaza, here they could run around in the forest, discovering all sorts of reptiles, insects, and birds and trying out their bows and arrows on something other than melons. The sounds of the camp echoed against the wall of trees, creating a pleasant, slightly mysterious ambience. Soon, the first men had already returned. While still quite far away, they started singing in a high falsetto. The songs reflected the kind of animal they'd hunted, so the women knew who'd killed what. ▌

Gustaaf Verswijver, Mekranoti

Nomadic people travel *in* their territory rather than *through* it. Their medium is space not time.

In southern Africa, Kalahari San babies begin life being carried, usually in slings, on their mothers' hips for thousands of miles before they walk freely on their own. A baby or toddler is carried in this way by their foraging mother for up to three years. When the infant is most acutely observing the world she is right in the thick of action absorbing every sound, sight and smell. As the band moves, her mother and others in the group name everything they come across. There is a powerful coming together of the warmth and rhythm of the mother's body, the company of others in the group and the unfolding environment.

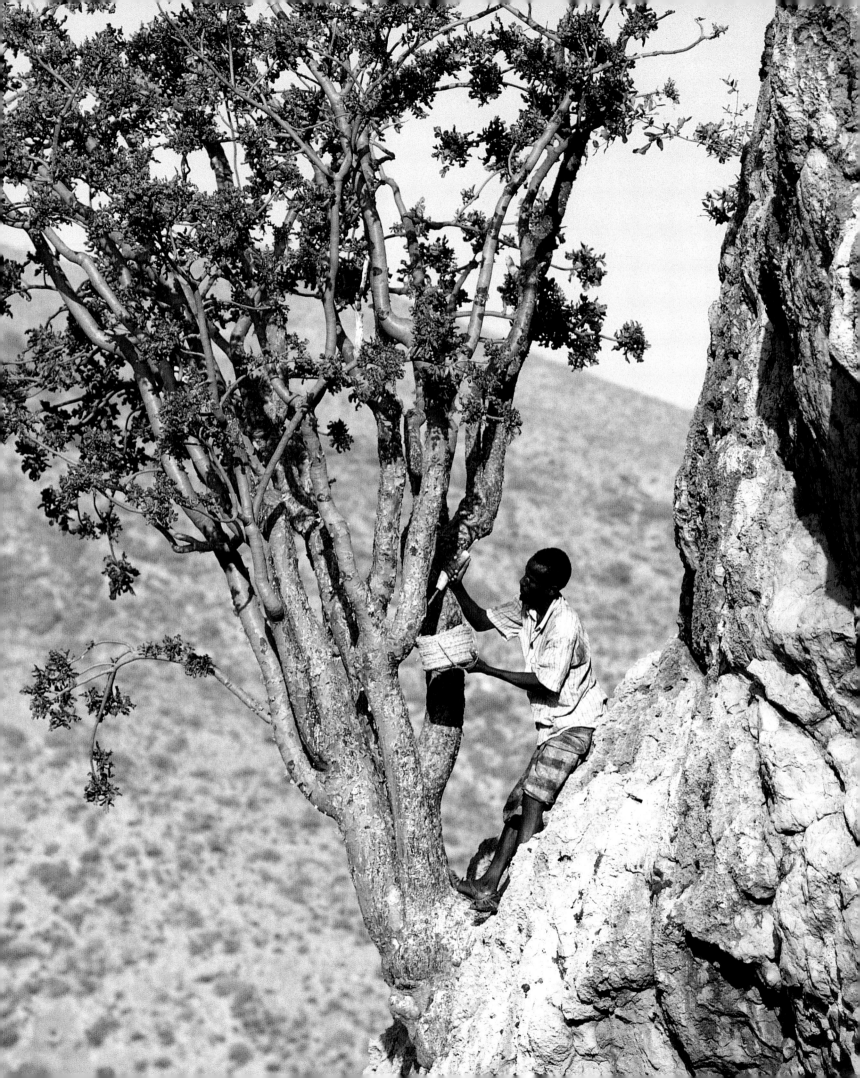

At last the long shadows in the snow grew blue like the sky. The shining left the edges of the ice and the long shadows drew away like the edge of an ice field moving slowly out from the land. Still the traces of the dogs did not touch the ground. There was not much light from the stars, and we stumbled. When the moon did rise it was only half a moon. It did not give us much light, and we stumbled, and there were wails from the dogs and that was because we were now truly tired and it took much shaking to keep our children awake. 'Tiamak (Here, now, that's it),' I said, 'We will stop.'

The Story of Comock the Eskimo [Inuit]

The lives of nomadic people have changed. In the past century, many have been induced, or forced or chosen to settle. The Sami reindeer herders of arctic Scandinavia have virtually given up nomadic ways. Only those now nearing the end of their lives can recall being brought up in tents. Today Sami people live in houses and travel for brief periods in the year to hunt or mark their reindeer. They get about by plane and snowmobile. The same is true of Inuit hunters of Canada and Alaska. Like igloos, their dog-drawn sledges are largely things of the past.

Many nomadic people have resisted and continue to resist being absorbed into the settled world. Some have adopted elements of industrialized culture – such as artifacts and trade goods – the better to preserve their life on the move.

The Bedouin trade milk, meat and carpets with their more sedentary neighbors in exchange for tea and coffee. The coffee urn occupies pride of place in the men's section of the tents because offering coffee has become a means of offering hospitality to visitors.

Somali herding nomads earn money by raising animals, and from other activities:

My father periodically ventured into a village and sold an animal in order to buy a sack of rice, fabric for clothes, or blankets.
Another way we made money was by harvesting frankincense, the incense mentioned in the Bible. Its scent is still a valued commodity today. It comes from the **Boswellia** *tree which grows in the highlands... its limbs hang in a curve like an open umbrella. I would take an ax and strike the tree lightly – just enough to slash the bark. Then the tree would bleed a milky fluid... I waited for a day for the white juice to harden into gum. We gathered the clumps into baskets, then my father sold them. My family also burned frankincense at night in our campfires in the desert.*

Waris Dirie, Somali, East Africa

Most nomads have to trade to obtain iron or iron goods. For this reason, Gabra people value highly a small basic forge that enables them to manufacture metal products they need. Machetes, guns, bullets and cooking pots are also favored trade goods. Another is dried maize which helps them survive drought years. Apart from trading their own products to acquire these items, the members of some groups – Central Africa's Baka and Mbuti rainforest people for instance – do casual work on farmers' smallholdings.

As part of their trading activities, Tuva people in Mongolia need to travel:

People say that someone has 'gone into the salt' – dustaar – is on a caravan and may return at any time. At one time there were great caravans which brought salt. That was the salt journey.

Galsan Tchinag, Tuva, Russia/Mongolia

Gathering frankincense, the aromatic gum, Somalia

When we had camels we women always worked together. In that way work was entertainment. Milking a camel required at least two women – one to hobble the animal and keep other camels away and another to collect the milk. Not only milking, but also making cheese and weaving rugs had once been pleasurable co-operative tasks for women. And packing and unpacking camp was always entertaining in the old times.
One never knew just how many times the women, who always rode on the camels, would fall off!

Bedouin woman

Of all the nomadic people, Bedouin are perhaps the most famous. And certainly one of the most photographed with their noble ships of the desert – their camels. But today many Bedouin have become settled. And of the others, many have forsaken camels for trucks. Camels, they say, 'became too difficult to care for'. Camels' tendency to wander off for miles snacking on shrubs and grasses, and to bolt when a family group was moving camp, often damaging their owners' personal belongings, meant that they required constant supervision. Another problem was the increase in agricultural development in some areas. Orchards in particular proved irresistible to camels. But the last straw was the introduction of paved roads and motorized traffic. On slippery road surfaces, camels' feet – so effective on sand – are a positive hazard.

Bedouin who have exchanged camels for trucks have shifted to herding sheep. They appear to have no trouble transferring affections they once lavished on camels to their vehicles.

❚ During the dry season, there was not one day in which a truck parked by a *beit* (encampment) was not cleaned and dusted by the men as well as small boys. Unlike other mechanical instruments (eg, tape recorders, radios), these vehicles were constantly cared for. Scratches were covered, engines were kept in tune, dents were removed, and the body of the vehicle was always gaily decorated. Talismans and proverbs to ward off the 'evil eye' were always found somewhere on the vehicle as were tassels, photographs, and mementos. ❚

Dawn Chatty, From Camel to Truck

But it seems that women regret the passing of the camels, which they decorated with woven tassels and ropes. They have no part in the decorating, cleaning, or mechanical repair and upkeep of the vehicles.

The trucks make it easier for the Bedouin to move camp, take fodder and water to their herds and get their produce to markets. They have not dented their commitment to life on the move nor their fierce protection of their autonomy. But there are signs that trucks are affecting not just the way people relate to each other but also some of their links to their environment – for example their tracking skills are being eroded.

Tuareg people, living mainly in Algeria, Libya, Niger, Burkina Faso and Mali are also animal herders, many still herding camels. And for some, life ideally will not change:

This is the life of my ancestors. This is the life that we know. My father was a nomad, his father was a nomad, I am a nomad, my children will be nomads. The animals are my life. If the animals die, we die.

Inaka, Tuareg, Sahara

Tuareg with camels, near Djanet, Algeria

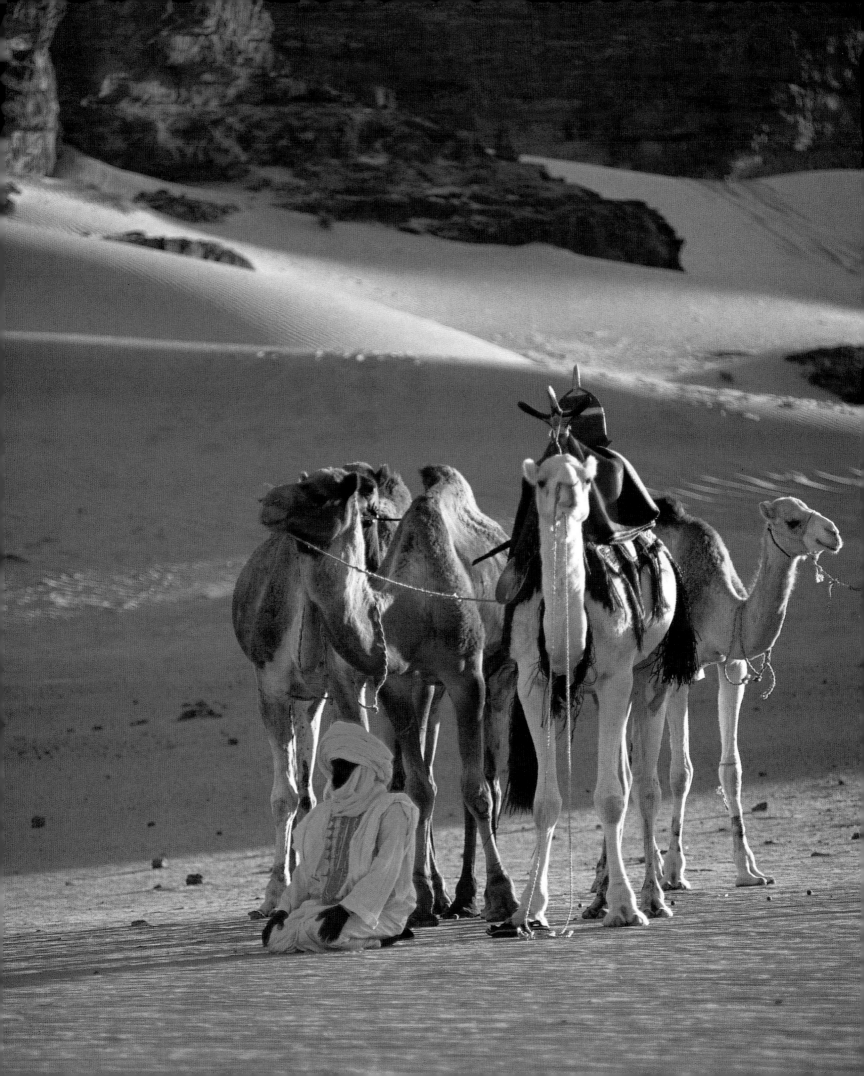

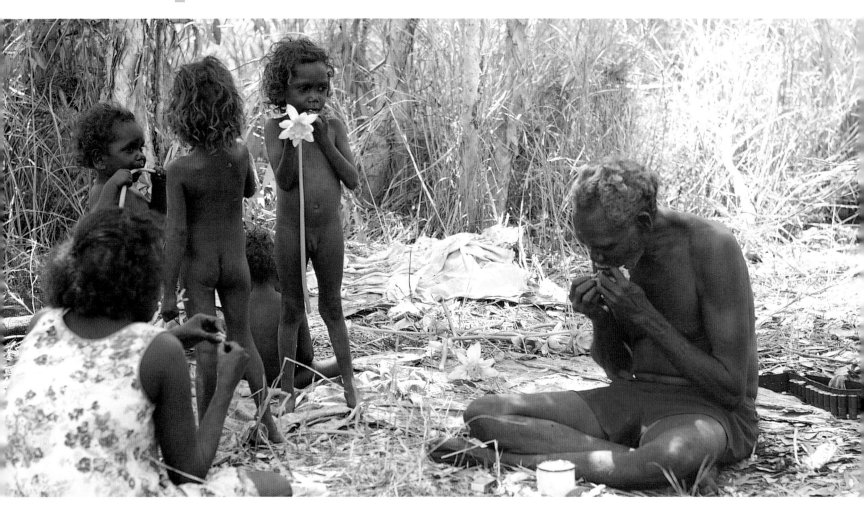

*T*he Aboriginals are true lovers of nature. We love the earth
and all the things of the earth... It is good for the skin to touch
earth, to walk with bare feet on the sacred earth.

Anne Pattel-Gray, Aboriginal, Australia

People on the move to search for game and other foods in the rainforests or dry lands may have no more in the way of personal possessions than a few items of clothing, some personal or ceremonial decoration and a few tools and weapons – amounting on average in weight per person to less than half the standard airline baggage allowance.

Those who shift most often and by the simplest means – San in southern Africa, Australia's Aboriginal people and some Amazonian Indian groups, among others – are able to carry least. Effective shelter is made from materials to hand, usually grass, sticks and leaves. With some women carrying babies and other members of a band moving with weapons at the ready, not everyone can take a full load. Prefabricated shelter, such as the large woolen tents made by the Bedouin, would be too heavy and cumbersome to carry. Nomads whose herds include beasts of burden – donkeys, horses or camels – can have more possessions.

Our home was a hut woven from grass; being portable, it served the same purpose as a tent. We built a framework from sticks, then my mother wove grass mats that we laid over the bent twigs to form a dome... When it came time to move on, we dismantled the hut and tied the sticks and mats, along with our few possessions, to the backs of our camels.

<div align="right">

Waris Dirie, Somali, East Africa

</div>

Like other East African herding people, the Gabra don't generally ride camels but they do use them to carry mothers with their newborn babies, as well as pregnant women and old people. 'Camels are our trucks,' they say.

But the lack of interest in accumulating personal property – aside from animals for some groups – has a wider frame of reference than what a person can carry. People who practice nomadic ways see their most important investment and greatest security as being in their relationships with their group and in its collective knowledge of their local area.

Land is not owned individually. It is part of the environment in which the people and all other creatures and plants belong. Names nomads choose for themselves that translate as The People, The Real People (Inuit), or the True Human Beings (Huaorani) place them at the center of their material and spiritual world, occupied by their ancestors, some believe, since time began.

Like other nomads, Penan people of the Ubong River in the Borneo rainforest celebrate their surroundings as the basis of life:

Here our food can never run out. And we are always happy because the water is clear, and the forest is always a delight to us... thus our life has been since our origins.

<div align="right">

Lejeng Kusin, Penan, Borneo

</div>

The sense of being part of the natural environment is something that those who hunt and forage for food – like Australian Aboriginal people – express almost palpably:

Aboriginal people... love the soil and we sit or recline on the ground with a feeling of being close to a mothering power. The feeling of our relationship to the earth is so strong that we feel parts of the land which belong to our Dreaming are like parts of our body.

<div align="right">

Anne Pattel-Gray, Aboriginal, Australia

</div>

Aboriginals in Arnhemland, Australia

Across in Central Africa, Congo Mbuti people refer to the forest as their mother or father:

▐ Not more than a few hundred yards from the edge of a village plantation, it was as though the village world had never existed. The sky was shut out by a mass of foliage high overhead; the sounds of the village were quickly lost. The crowing of roosters was the last sound I heard until all were replaced by the myriad forest sounds – rustles, rumbles, whispers, tap-tap-tappings, snappings and thumpings, providing a muffled foundation for the build-up of the sounds of all the living things that burrow and crawl and run and jump and fly in this living forest world of the Mbuti.

The young Mbuti with us were themselves making forest sounds and shouting out to the forest, *'Ema, Eba, zu kidid, zu kidi 'o'* – 'Mother, Father we are coming!' ▐

Colin Turnbull, The Forest People

Nomadic people not only own very little, they produce very little and consume few of the world's resources. In the past, almost everything they needed to survive – food, shelter, medicine, clothes – they procured from their environment, or in the case of herders, from their animals. This was made possible because their requirements were simple and because they used great ingenuity with few resources.

Baka pygmies, rainforest dwellers in southern Cameroon in Africa, erect effective shelters by creating a domed structure of sticks. They then splice the thick stems of the large leaves of a particular plant so as to be able to hang them over the frame, like shingles. In Borneo, the shelters made by Penan are stoutly-made, lashed-pole structures with a living and sleeping platform raised on stilts and a gently pitched roof. They take about four hours to build.

Other things can also be fabricated from what is to hand. In northern Alaska, Inuit people used to make cooking pots from bark. Lucy Foster Aqubluck, who as a young child led a nomadic life with her father, recalls how he would strike flints to ignite the fluffy seeds from willow trees to set a fire and boil fish and meat in a pot made of birch bark with split-willow rims sewn together with willow roots. This conjuring trick was achieved by filling the pot with water and successively dropping into it flat stones made red hot in the fire.

Rainforest pygmies gather their food both on the ground and high up in the forest canopy. They move about in trees with great agility and confidence in their quest for honey, fruits and other arboreal products. A Baka hunter encircles both a giant tree trunk and his waist with a hoop of vines. He uses the hoop to gain a purchase with his feet against the trunk that may rise 120 feet before it produces great lateral branches. Once he has eased himself on to a branch he walks around with the confidence of a steeplejack. Some Amazonian Indian groups bind their ankles with vines so that by splaying their knees they can exercise a vice-like grip with their feet on narrower tree trunks.

Penan people in the forests of southeast Asia go one better. They are very fond of pet monkeys that also prove invaluable allies in their gathering pursuits:

When we go out walking with our animals, like the long-tailed macaques and the pigtailed macaques, it's really good... because they are like people, and they climb up and get fruits for us to eat down here on the ground. When we are walking, if we should come across a snake, or something else dangerous, they will discover it before we do... in this way they protect us from harm. And if we should encounter evil people, either ahead of us or behind, they notice them first because their eyes are very sharp, and their hearing is good, too, so they notice right away.

Lejeng Kusin, Penan, Borneo

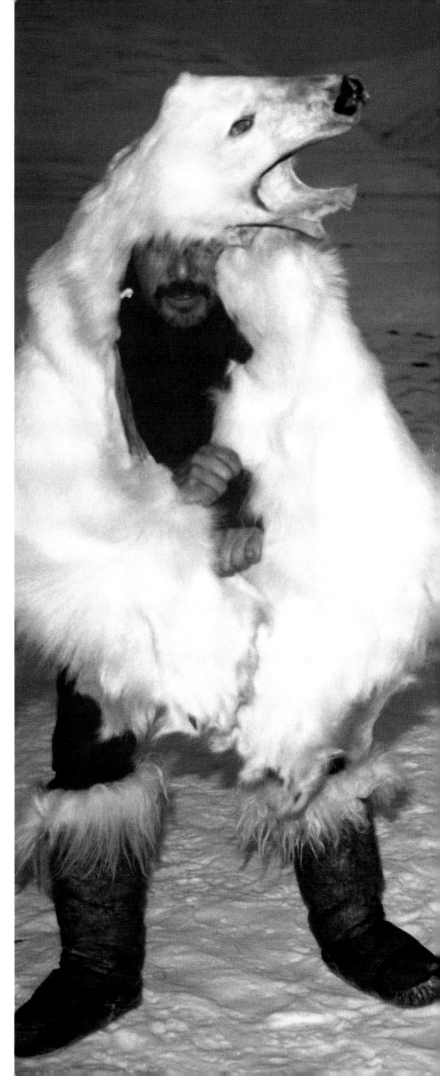

SKILL AND ENDURANCE

To extract a living from their environment nomadic people need skill, courage and endurance. For millennia Inuit people of the polar region braved the icy seas and rocky fjords in all weather to hunt whales in flimsy one-person canoes *(kayaks)* clad with sealskin or in somewhat more substantial craft called *umiaks*. They used hand-made harpoons tipped with ivory or walrus tusks to catch sea mammals like the giant white whales which were capable of leading them on a death-defying chase, plunging to the icy depths and exploding to the surface.

On winter ice Greenland's Inuit nomads used their sledge-dog packs and spears to hunt polar bears in near darkness. Getting close to a bear, they would release their dogs which were trained to attack bears. While the bear was busy with the dogs, sideswiping them with its giant paws, the hunters would come in very close to unleash their spears. There are stories of infuriated bears standing at full height snatching spears from their bodies, breaking them like matchsticks and flinging them away, before succumbing to their wounds.

▌ The Polar night should not be visualized as being pitch black, which it never is. Either it is lighted by the moon and stars – what we would call a clear night – or the moon and stars are hidden by clouds but still provide some kind of light. The Eskimos [Inuit] are obliged to hunt in all kinds of weather... They are able to find their bearings, no matter how dark it is, by using the snow as a reflector. Also, after mid-January, far away to the south at the far reaches of the horizon, a pale, sometimes reddish, solar halo appears; it emerges from behind the ice field in the southern latitudes and transforms the darkness into an eerie twilight.

During a clear or total night, the ice is a bluish gray spotted with grayish white; coastal spurs loom in the distance, shadowy and hostile. Icebergs are immobilized in the frozen sea and become friendly dark masses that serve as landmarks. When men move about, they are silhouettes darker than the night itself, and they seem to sense each other's presence rather than actually to see one another. I very quickly became able to see in the dark, but, of course, my night vision will never be as good as that of an Eskimo, which is prodigious. One night early in January, on the big slope at Innartalik, I saw Iggianguaq shoot at a white hare from fifteen hundred feet and kill him outright, although I could not even make out the animal. ▌

Jean Malaurie, Last Kings of Thule

Bedouin girl, Somalia

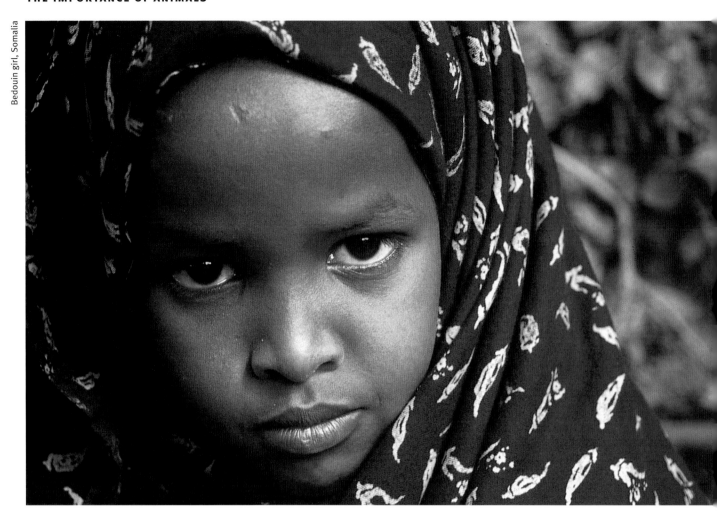

Hunter-gatherers experience at first hand how their natural world provides for them. For herding people, it is their animals that are nurtured directly by their environment and then in turn the animals supply most of the needs of the herders' families. Learning to care for the grazing beasts starts young:

By the age of six I was responsible for taking herds of sixty or seventy sheep and goats into the desert to graze... getting a head start was important, to find the best spot with fresh water and lots of grass. While the animals grazed, I watched for predators.

Waris Dirie, Somali, East Africa

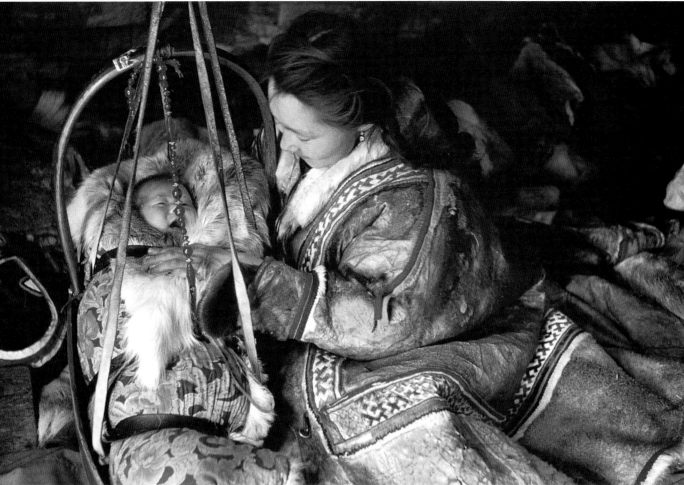

In a tent made of reindeer skin, a Nenet mother comforts her baby, Siberia, Russia

Each Spring among the Nenet reindeer-herding people in Russia, those few who still follow the old ways move their animals from the winter location in the forests of Western Siberia to graze on lichens and other plants beneath the melting snows of the tundra of Russia's Yamal Peninsula, well inside the Arctic Circle.

Unlike their Sami cousins, Nenets still make the 200-mile journey on caribou-drawn birch sledges that they make without the help of screws or nails. Though they have adopted a few products of the industrialized world – bowls, jerry-cans, tea, radios – they consider most of the range of consumer products to be superfluous. Life for a Nenet nomad begins and ends with caribou. New-born babies are wrapped in deerskins, as are people when they die. Throughout their lives people wear outdoor clothes, hats and shoes that they fashion from deerskin. For thread they use caribous' tendons. The blood and meat of the animals as well as the milk are key components of their diet. Their shelters, known as *chums,* are cones of stout poles clad with deerskin.

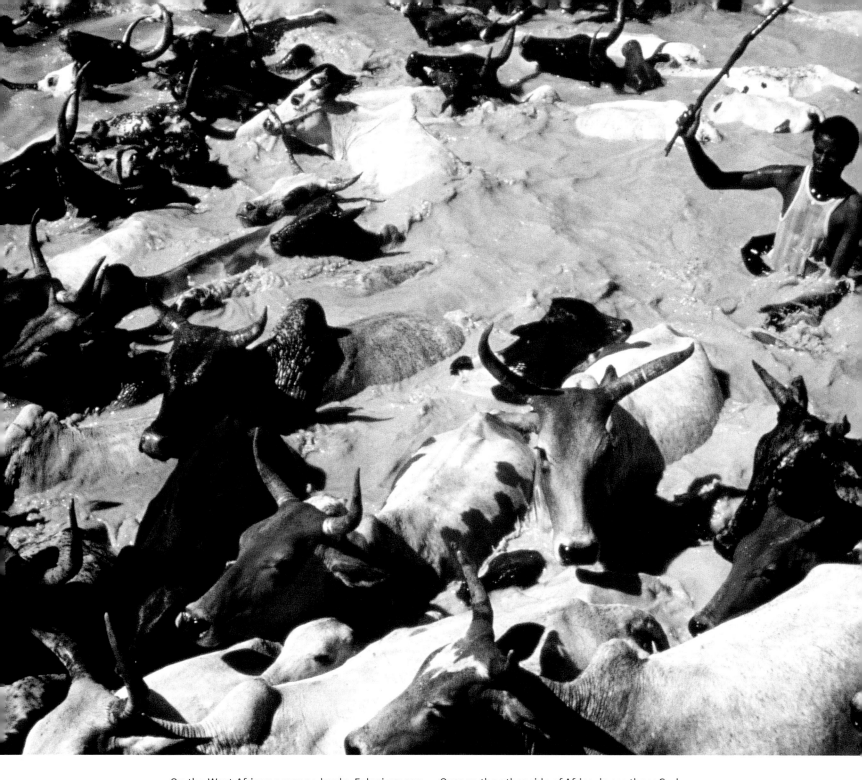

On the West African savanna lands, Fulani groups move with their cattle in small independent communities living in camps that blend with the bush. A girl learns to make milk and butter from an early age and her role in life once married is to bear and rear children and follow her husband. From childhood, boys are immersed in the world of cattle. When he receives his first calf, a young boy begins to imitate the men in their handling of cattle: caressing them, removing their ticks and singing to them and about them. Cows are beloved members of the family, known by name and treated with affection.

Over on the other side of Africa, in southern Sudan, Dinka people move their cattle away from the seasonal flooding of the Nile to temporary camps in the savanna forests. They choose names for cattle which link their appearance with features in the environment. So, a man with a black ox may be referred to by the admired appearance of the beast; 'Thicket of the buffalo' suggests the dark forest in which the buffalo rest; 'Cries out in the Spring drought' is after a small bird which calls at that time of year; 'Spoils the Meeting' after the dark clouds which bring a downpour and send men at a meeting running for shelter.

Fulani herder and his cattle crossing a river, Mali

My cattle arise and go,
they make the earth tremble.
They shake the trees,
divert the streams,
Muddy the pools and
clear the thicket.
My cattle bellow,
the antelopes flee.
My cattle bellow,
it puts the buffalo to flight.
My cattle bellow, it sets
the baboons barking.
It turns the deer away and
brings good fortune near.

Fulani poem, West Africa

As well as singing to their herds, young Dinka men stand with their arms gracefully curved above their heads to appear handsome, imitating the sweeping horns of an ox.

East African herding people talk about their animals with the same affection and respect that hunting and gathering people speak of the physical environment. Stock herders sing to their animals, attribute individual identities to each animal and praise the features of their beasts. Cattle are the warp, the basis of life. They are the only wealth, the foundation of economic and social stability, the origin of all human ties.

Nomadic people make little effort to manage or control the natural world, many believing that the less human interference the better. Instead they invest in understanding their surroundings, reading the multitudinous signs and learning to operate successfully.

Skills and insights are acquired through doing – a process that starts as soon as a baby is able to observe. Very young Bedouin boys and girls know how to recognize the footprints of each individual camel in their family's herd:

▌The tracking abilities of a seasoned nomad are positively uncanny. Even when the spoor is unfamiliar, the Bedouin can tell the camel's sex, whether or not it was being ridden, whether pregnant, where it had been grazing, when it had last been watered. The depth of the footprint indicates whether the beast was carrying a rider or baggage and thus determines the sex: riding camels are females because they have a gentler gait; pack animals are bulls because they can carry loads of up to 400 pounds. If the footprints show the impress of loose strips of skin, the Bedouin knows that camels have come from the sands; if the prints are smooth, that they have come from gravel plains, which polish footpads hard and smooth. ▌

Library of Nations, Arabian Peninsula

People also pass on knowledge by telling each other in detail what happens in the course of their day. If someone is away from the group for a period, they will be told upon their return everything that happened in their absence. Accounts of a hunt are followed closely – there could be new tips to learn. Know-how is also absorbed through myths and legends and by taking part in ceremonies.

For example, initiation into Aboriginal adulthood includes learning songs and chants that map each detail – each depression, valley, rock, clump of trees in their tribal territory. The world originated during the Dreamtime when their ancestors, part human and part not human, walked the land singing or chanting each feature of the landscape into existence. Each new generation has a sacred duty to repeat this singing of the landscape to ensure that the world stayed in place. A benefit of this practice was made vividly clear to writer W E Harney and his friends when crossing the north-western desert:

▌My truck broke down. I had some water, but not enough to keep my native passengers and myself alive if our engine fault proved to be serious. It was 60 miles (100 kilometers) to the nearest water, but an old Aboriginal told us not to worry, for, although he had never been in that locality, he knew the map-chant of the area. So, while we worked on the engine, he sang his chant. A long while he chanted, till he came to the landmarks that stood around us, and in the cool of the evening, he made us walk with him as he chanted. We obeyed. His song now was of a low hill before us, and from it, the story went, we would come upon the markers of stone that pointed to water. We climbed the hill and saw the cairn of stone laid down by an early Aboriginal explorer, and below it was a line or rocks that pointed to a low depression of limestone. To it we went, and there, under a covering of logs and grasses, was a limestone crevice that led into a small pool of crystal clear water. As I bent down to drink at that native well, I saw a new meaning in the song cycles of these so-called primitive people. ▌

W E Harney, Content to Lie in the Sun

Aboriginal man taking part in the Festival of Pacific Arts, 1988

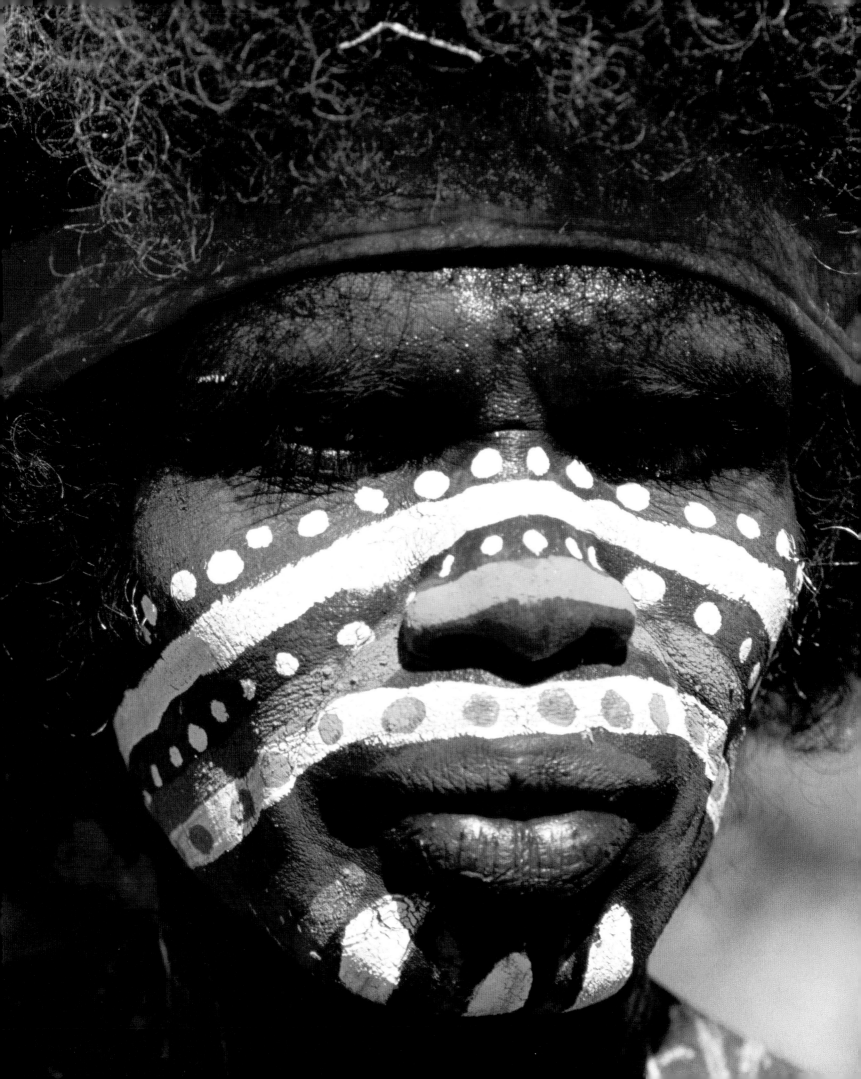

Nomadic people of every kind are both efficient users of their territory and also its wise guardians. In the absence of outside intervention, their populations remain stable. On the move, women gathering food can carry only one small child at a time. The Mekranoti Indians in the Amazon, like others, try to space their children. They take plants to which they attribute contraceptive qualities. Mothers delay their pregnancies by breast-feeding infants for three to four years and by periods of abstinence from intercourse. But of course population growth is also held down by disease and untimely child death.

Environments inhabited by nomadic people have their moments of plenty. It is the rainy season for Gabra families in northern Kenya. Drought years aside, torrential rain falls for a single month, with a transforming effect as dramatic as snow.

▌Stream and riverbeds that lie desiccated for most of the year are suddenly surging with life. Water lies everywhere. Grasses shoot up to cover the otherwise windswept, lunar landscape – composing a mantle of many greens and myriad colored flowers. The animals are so full of milk that they can be milked three times a day. Grazing is everywhere at hand so the sheep and goats, cattle and camels all can stay close to the villages, which enables the young men to live at home.

The women and girls do not have to spend long tedious hours fetching water, nor do the men have the laborious task of watering the animals at faraway wells.

The rainy season is the most beautiful season. There is an atmosphere of relaxation, of repose and abundance in the villages – a season of blessing of replenishment for both people and animals. ▌

Paul Tablino, The Gabra

Preservation of the environment is also evident in the limited cultivation practiced by some nomadic groups.

▌Mekranoti Indians [in the Amazon] clear a small area of forest and then burn the debris. In the ashes, both men and women plant sweet potatoes, manioc, bananas, corn, pumpkins, papaya, sugar cane, pineapple, cotton, tobacco and annatto, whose seeds yield *achiote,* a red dye used for painting ornaments and people's bodies. Since the Mekranoti don't bother with weeding, the forest gradually invades the garden. After the second year, only manioc, sweet potatoes and bananas remain. And after three years or so there is usually nothing left but bananas. Except for a few tree species that require hundreds of years to grow, the area will look like the original forest twenty-five or thirty years on. ▌

Dennis Werner, Amazon Journey

Mekranoti people, who say they used to be on the move more frequently in the past, still go on hunting and gathering treks into the forest for weeks and even months on end. They plant small fruit and vegetable gardens alongside the tracks they cut through the forest to provide them with supplementary supplies on future treks. By these means they guard against depleting animal stocks and over-cultivating any one area.

In Ecuador's Amazon rainforest, Huaorani Indians live together in isolated groups in longhouses. They practice a much simpler form of cultivation than Mekranotis. They do not burn or even weed a patch, but plant manioc/cassava in among the other plants and harvest it once. Because they move frequently, they help – both intentionally and by throwing the seeds of the fruits they eat on the ground – to enrich the distribution through the forest of fruiting and other useful trees and plants. By living in tune with their environment rather than through productive work, they help ensure that the forest continues to supply them in abundance.

People who live by hunting and gathering have a detailed understanding of their environment. Huaorani people are well aware of the animals they hunt which eat the same plants and fruits they gather. They experience themselves as co-sharers of the rainforest with the animals, never fully harvesting fruit trees because monkeys also eat the fruit.

Respect for their natural world by nomads searching for food, and from those moving with their animals, is underpinned by worldviews that unite the material with the spiritual universe, the heavens and the earth and the living and the dead. From these perspectives the world is anything but simply material.

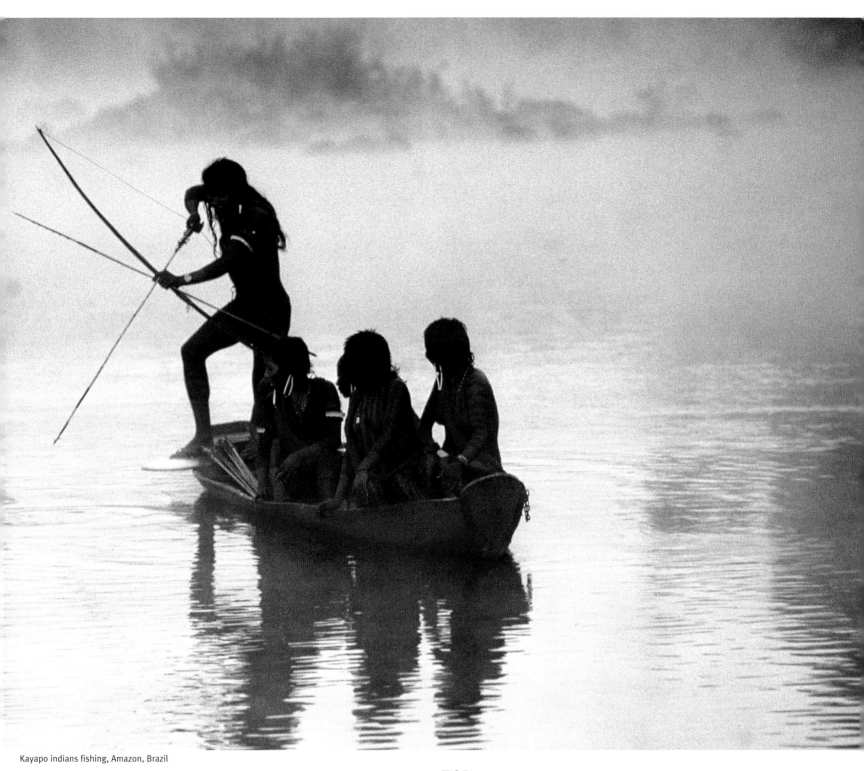

Kayapo indians fishing, Amazon, Brazil

We live with the spirit of the jaguar.

Moi, Huaorani, Ecuador

██ The Mekranoti of Brazil once lived in a world above the sky where everything they wanted was in abundance – creatures to hunt, sweet potatoes, corn, manioc and bananas. One day a man, hunting in the forest, discovered an armadillo's hole. Resolving to bring the game back to the village, he dug and dug until nightfall, but the creature eluded him. After several days of burrowing into the red earth, he finally sighted the giant armadillo. But in his excitement he punctured the celestial ceiling and the animal fell through the hole. The world below was just like the one above, full of palm trees, savannas and rivers. The man returned to his village to tell the others of his discovery. After much discussion the Indians decided to move to the new world. Gathering together all the cotton cords they could find in the village, they made a giant rope to descend to the forest below. First went the young men, then the women with children on their hips, and finally the fathers and elders. Some people were afraid to come down and so remained in the world above. A child cut the rope, and then it was no longer possible for anyone else to descend to this world. ██

Dennis Werner, Amazon Journey

All societies have myths about how the world began – told through stories and rituals handed down through the ages. Myths sometimes change to account for new developments like the arrival of colonists.

Some groups believe that their ancestors discovered the world, others that they played a part in creation. Yuquí people in Bolivia believe that their early ancestors, the Abá, were the creators:

*T**he first living things on earth were the Abá. Some very old animals that were with them were the tapir, jaguar, white-lipped peccary [wild pig], and the deer. Then the Abá… gave birth to the Bía [Yuquí].*

It was dark, there was no sun or moon. Because it was dark, the Abá heated up his grease – alligator, jaguar, peccary, tapir. When it was hot he poured it out. That was the sun. Some splashed around, making the stars. The rest stayed in the round pot, getting hard. That was the moon.

Yuquí, Bolivia

Aerial view of the Amazon floodplain, Brazil

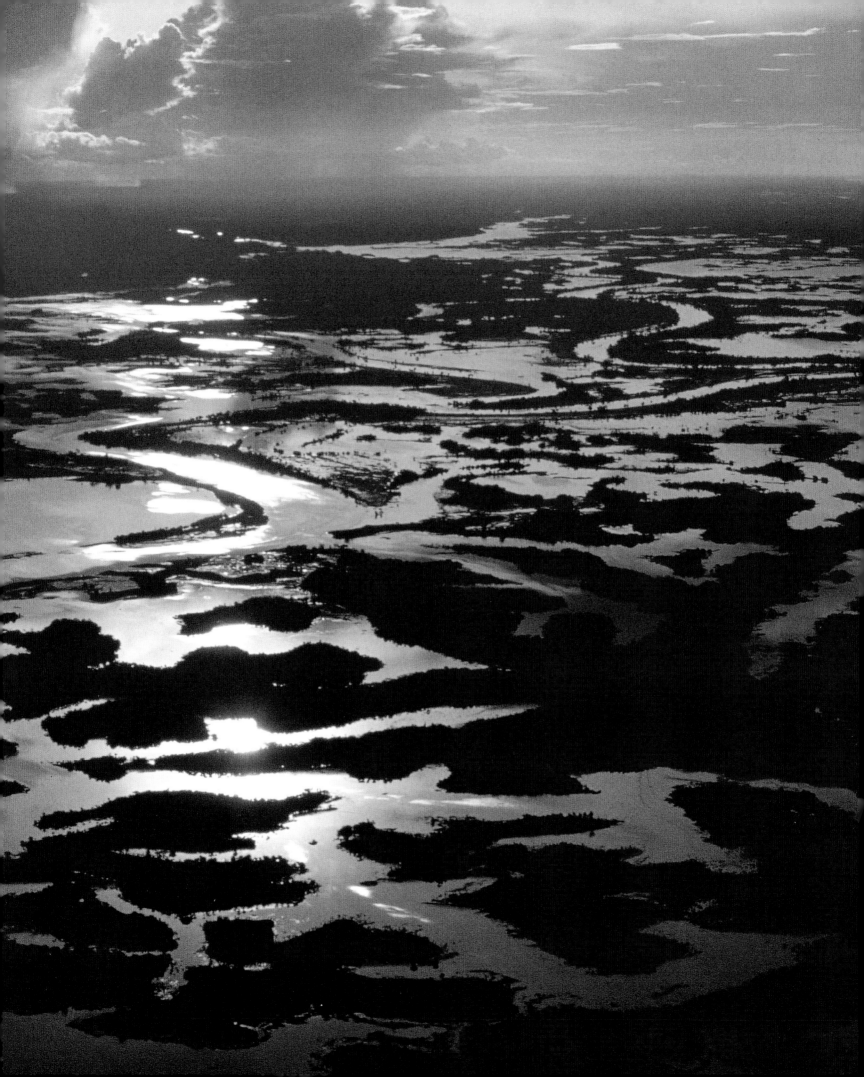

In Australia, the Aboriginals' ancestors called the earth and the sky into existence during the Dreamtime. Then they made people from particular plants and animals that became those peoples' totems or tribal spirits. Aboriginal rock painting and drawings on bark record this act of creation. The spiritual and mystical beliefs of Aboriginal people link them powerfully to the land.

Only through our spiritual connection to the earth can we continue in our own identity... We conceive of ourselves in terms of the land. In our view the earth is sacred. It is a living entity in which other living entities have origin and destiny. It is where our identity comes from, where our spirituality comes from, where the Dreaming comes from.

Anne Pattel-Gray, Aboriginal, Australia

Some myths of origin tell of a fall from grace through some kind of original sin. In Africa's tropical rainforest, an Mbuti mythical ancestor killed an antelope and then ate it in an attempt to conceal the act of killing. From then on all animals and humans were mortal. This belief leads the Mbuti to be gentle hunters.

▌At the moment of the catch, as much as they look forward to the subsequent feasting, I have never seen any expression of joy, nor even of pleasure. It is as though, at that moment, they are totally without emotion. And they say, 'If only we could learn to live without killing, we might regain our immortality'. ▌

Colin Turnbull, The Forest People

A beneficial outcome of this belief is the conviction that to kill more than is absolutely necessary will reinforce the consequences of the original sin and confirm even more strongly the Mbutis' mortality. Like many traditional hunting peoples, Mbuti people are conservationists with an unbounded respect for life, in all forms.

THE MAKING OF THE UNIVERSE

Many stories tell how important elements in the environment came into being. These myths often reflect a notion of fluidity between different life forms allowing for people to transform themselves into animals or plants.

The tiger and the crocodile, the two most dangerous creatures in the Borneo rainforest, came into being after two Penan brothers, angered by their mother, ran away from their village. On coming to a stream they agreed that if one landed on the opposite bank he would become a tiger and if one fell into the water he would be a crocodile. Once transformed into these creatures, they agreed that they could attack and kill people only if they had done something bad. Similarly the Penan believe they cannot kill the tiger or crocodile unless they have done something bad because in reality they are Penan.

Not surprisingly the night sky, seen in all its glory undimmed by the veil of electric light, is the focus of many myths and stories. A Sami girl in the mythical time of Russia's reindeer herders took pity on a boy who had pursued her. She ran up a mountain to escape him and went into the sky. As he collapsed in despair at having lost her, she tried to pour milk between his lips to revive him. But the wind took the milk and spread it across the sky where it turned silver and became the Milky Way.

Crocodile surfacing, Thailand

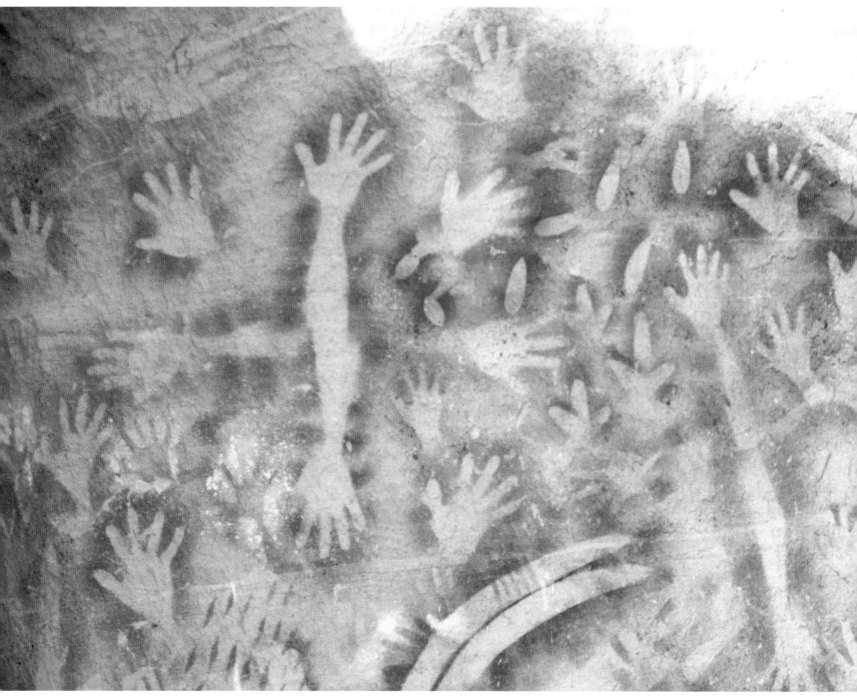

Aboriginal rock art, Queensland, Australia

Aboriginal creation stories can be funny, whimsical and poetic. A story tells of how Darama, the Great Spirit, created ancestors Toonkoo and Ngaardi and explains how the aboriginals got the boomerang:

One day, Toonkoo said to Ngaardi that he'd go out hunting. He went out hunting kangaroos and emus, while Ngaardi stayed home and got some bush tucker. She was waiting and waiting, but Toonkoo never came home.

She started worrying. Then she started crying and as the tears ran down her face, she made the rivers and creeks come down that mountain.

She waited there all day for him to come back with the food, but he never came back.

As Toonkoo was out there hunting, he chucked a spear and got a kangaroo.

Then he walked a bit further and he looked up and saw Darama, the Great Spirit, up in the sky, watching him. He chucked a spear up to the sky, up to hit Darama, but Darama caught it, bent it and chucked it back. As it came back it turned into a boomerang.

Warren Foster, Aboriginal, Australia

Rainclouds over Botswana

For many the creator is benign. Gabra people in Kenya have faith in a god who created order in the world and who responds to their needs. Gratitude for the rain is expressed in their ceremonies:

He has sent the rain,
he has made us have rain,
he who is loving,
compassionate.
The thick clouds of rain,
in their season,
have reached the earth.

Gabra praise song

The forest world of the Mbuti in Africa is good not just because it provides for their needs but also because the spirit of the forest, *molimo,* actively cares for them. They don't attribute misfortune to evil spirits or witchcraft but rather to a lapse of attention. An elderly man, Moke, explains:

The forest is a father and mother to us and like a father or mother it gives us everything we need – food, clothing, shelter, warmth... and affection. Normally everything goes well, because the forest is good to its children, but when things go wrong there must be a reason.

At night when we are sleeping sometimes things go wrong, because we are not awake to stop them from going wrong. Army ants invade the camp, leopards may come in and steal a hunting dog or even a child. If we were awake these things would not happen. So when something big goes wrong, like illness or bad hunting or death, it must be because the forest is sleeping and not looking after its children. So what do we do? We wake it up. We wake it up by singing to it, and we do this because we want it to awaken happy. Then everything will be well and good again. And when our world is going well then also we sing to the forest because we want it to share our happiness.

Moke, Mbuti, Congo

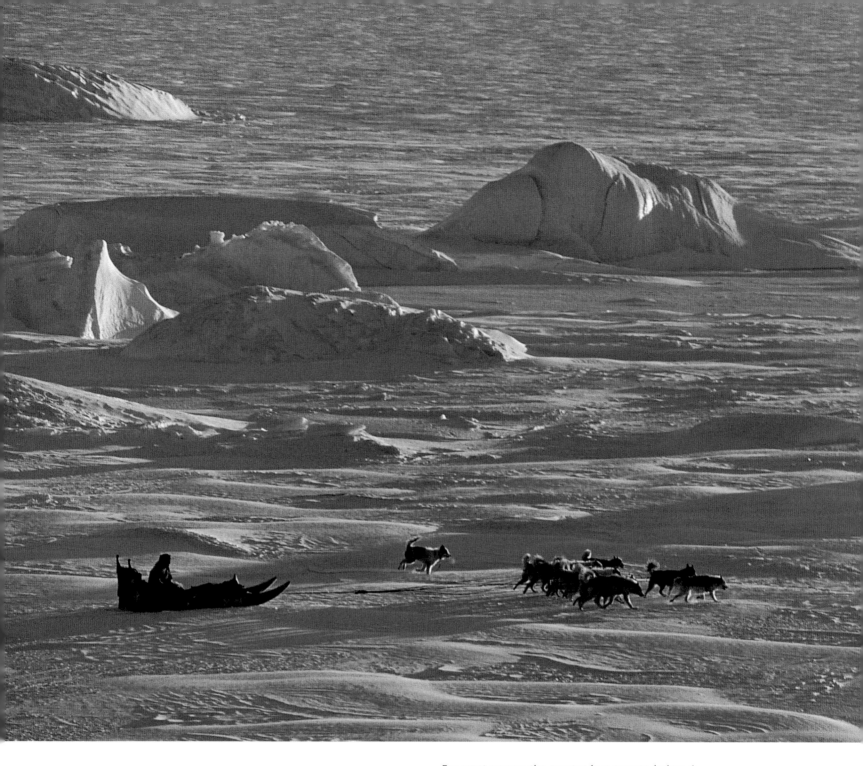

For most groups the creator is a remote being. A lower order of spirits permeates the material world and can bring fortune and misfortune into peoples' lives if due attention is not paid to them. Keeping the spirit world undisturbed is often synonymous with acting in ways that respect the balance of the natural world. Long after they converted to Christianity, Inuit hunters in Greenland, like Sakaaeunnguaq below, would consult their personal spirits so as not to interfere with the natural order and they turned to them at times of need.

Sakaaeunnguaq recalls a hunting trip towards the end of Spring in which he and his friend Olipaluk nearly perished when they became stranded:

*O*ne day we were sleeping on the shore. When we woke up, we saw that a catastrophe had happened: our kayak was gone. We had moored it on the shore with stones – but not securely enough. We had lost not only the kayak but everything else as well – our harpoons, our guns. We were prisoners: we could not go anywhere.

We tried living on roots, but we were tormented by hunger and had to eat our ten dogs; we used some of their fat and flesh as bait in ten traps we found nearby. One day I went up the mountain alone. I was famished. I prayed to Guuti [God] and also secretly – very secretly – to my familiar spirit, the one my father had taught me to respect.

'Make hares come to me!' I said to him.

Then I looked up, confident and yet a little uneasy. At that very moment, a white hare ran up in front of me, although for weeks we hadn't been able to find a single one. I killed it and we ate it. Soo Guuti! Thank you, God!

Sakaaeunnguaq, Inuit, Greenland

Inuit, like other hunting people, believed that the animals they killed gave themselves up to them. They did so because they wished to visit their human brothers in order to help them. It was the body not the spirit of the harpooned seal or bear that died. And it was incumbent upon hunters to ensure that the spirit of the animal felt welcome and was also helped on its way:

▎When he killed his first bear at nine, with a harpoon made for him the night before by a favorite uncle, he could not stop smiling. His first seal was taken when he was still too small to lift it from the ice. But he knew that the animal had chosen to die, betrayed by its thirst for fresh water. So he followed his uncle's teachings and dripped fresh water into its mouth to placate its spirit. If animals are not properly treated, they will not allow themselves to be taken. But if they are not hunted, the Inuit believe, they will suffer, and their numbers will decrease. Thus the hunt is a reflection of balance, a measure of the interdependence of all life in the Arctic. ▎

In Borneo, if an animal tracked by Penan hunters is wounded but does not die they will take it back to their house and nurse it carefully back to life. It will then be regarded as a pet and not to be eaten. Like the Mekranoti Indians of the Amazon, Penan are aghast at the way settled people eat their domesticated animals. They regard the killing of such 'pets' as murder, in contrast to the respectful practices used by Penan in pursuit of game.

Occasionally, when Huaorani indians of Ecuador are out hunting, a targeted monkey will make its 'soul' visible and 'speak with its eyes' pleading for its life to be spared and they will pass it over in search of other prey.

Spirits, or the universal spirit in its many forms, inhabit not only animals but plants and even inanimate objects, which also have to be treated with due respect.

Wade Davis, Shadows in the Sun

Dog-drawn sledge crossing the sea ice, Meteorite Bay, Greenland

Not all spirit beings are well disposed towards people or readily placated, which explains why things go wrong sometimes. Spirits in the world of the southern African San are sometimes kind and generous and at other times whimsical and cruel. They behave erratically, just like people, and this accounts for human life being unpredictable. They sometimes shoot people with invisible arrows carrying disease or misfortune.

Deer-hunting Inuit near the Arctic Circle in northern Canada were bedeviled by some singularly powerful and vindictive troll-like beings, symbolic of the ultimate destructive powers of both humans and animals.

▌ It was enough to see *Paija* – a giantess, with a single leg and flowing black hair, who stalked abroad on winter nights – to be stricken, frozen to death in horror. ▌

Farley Mowat, People of the Deer

Like many indigenous peoples, Penan believe that spirits are ultimately responsible for sickness and misfortune. The sources of malevolence and disease are several. *Penakoh* is a malicious and vengeful spirit that may seek refuge in the trunk of the strangling fig. A master of deceit and disguise, *Penakoh* lurks in the form of animals or demons, ready to betray the living. The wrath of other spirits is felt by those who ignore the omen birds or violate taboos by killing trees.

Generally, people can seek assistance from the spirit world to help them solve specific problems – problems related to hunting, the rain, health, harvests and conflict within their community or with outsiders. Through ceremonies and daily observances people can also help the supernatural powers keep the universe harmonious.

Sometimes intercession is achieved with the help of shamans, ritual specialists who are able to go into trances. In their states of altered consciousness they travel to the spiritual world often transforming themselves and becoming animals as they mediate between the human and spiritual realms.

Intercession often takes place with the help of others – dancing and singing, sometimes involving the use of hallucinogens. San dances most often happen spontaneously, after the first rains or after a large animal has been killed. The singing and clapping are essential to the dance, influencing the strength of *n/um* (the power) a healer will be able to summon forth. The healers dance around the fire sometimes for hours. Helped by the singing, the movement and the smoke and heat of the fire, the healers' intense concentration causes their healing power to heat up and sends them into a trance. While a healer's soul is absent, her/his body is in a state of half death. In this dangerous state, the power of other healers' *n/um* protects him. The other healers massage his body, rub his skin with sweat and lay hands on him until he regains consciousness and they know his soul has returned to his body.

Nisa, a !Kung San healer in southern Africa, explains
the difficulties healers can face:

N/um is very tricky. Sometimes it helps and sometimes it doesn't because God doesn't always want a sick person to get better.

I was a young woman when my mother and her younger sister started to teach me about drum-medicine. There is a root that helps you learn to trance, which they dug for me. My mother put it in my little leather pouch and said, 'Now you will start learning this, because you are a young woman already.' She had me keep it in my pouch for a few days. Then one day, she took it and pounded it along with some bulbs and some beans and cooked them together. It had a horrible taste... I drank it a number of times and threw up again and again. Finally I started to tremble. People rubbed my body as I sat there, feeling the effect getting stronger and stronger. My body shook harder and I started to cry. I cried while people touched me and helped me with what was happening to me.

Eventually, I learned how to break out of my self and trance. When the drum-medicine songs sounded, that's when I would start. Others would string beads and copper rings into my hair. As I began to trance, the women would say, 'She's started to trance now, so watch her carefully. Don't let her fall!' They would take care of me, touching me and helping. They rubbed oil on my face and I stood there, a lovely young woman, trembling in trance until I was finished.

I know how to trick God and how to have God give the person back to me. But I, myself, have never spoken directly to God nor have I seen or gone to where He lives. I am still very small when it comes to healing and I haven't made these trips. Others have, but young healers like myself haven't. Because I don't heal very often, only once in while. I am a woman, and women don't do most of the healing.

Nisa, !Kung San, southern Africa

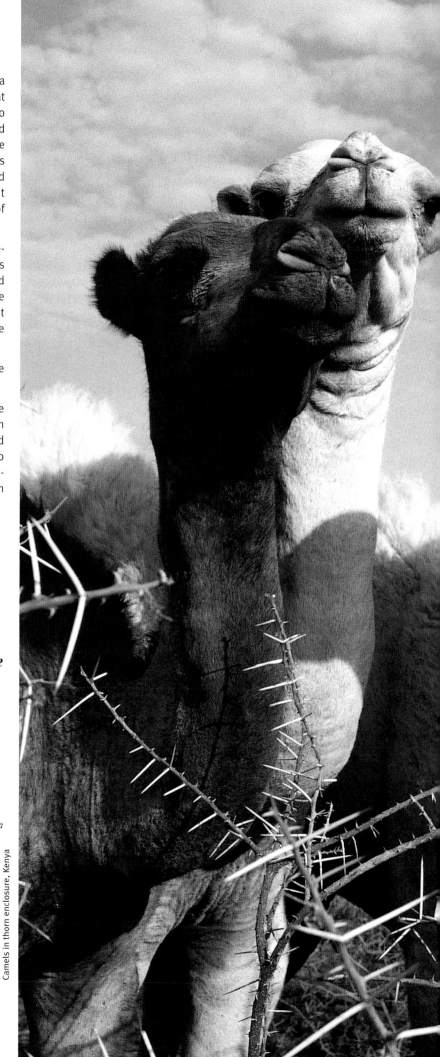

RAINMAKING

While as camel herders the desert-dwelling Gabra live a life that is very differently organized from that of hunters and gatherers, their ceremonies are also celebrations of life, emphasizing wealth, peace and harmony. The atmosphere of *Karso Naabo,* the Gabra rain-making ceremony, is festive and reflects the social order presided over by the elders. Held by two or more villages when rain is hoped for, it celebrates abundance and the benevolence of their god.

At dawn men and boys construct a *naabo,* a special enclosure of thorny branches. There the heads of the families gather. All about are the humped backs of camels and the white patches of the flocks, for during such a festival the herds are not taken out to graze; all people and animals must be present.

During the ceremony people inside and outside the *naabo* dance and sing.

The powerful voices of the men combine with the beating of sticks, the energetic leaping up and down of young men and rhythmic slapping of feet and clashing of metal rings of the dancing women to accompany the shrill voice of a soloist who presents a refrain for a chorus of singers to repeat in perfect harmony:

The camels' calves suckle the milk and we milk.
The camels' calves suckle the milk and we milk and fill our vessels.
The camels have returned, the enclosure is full.
And the children have drunk and are full of the milk of the camels. And also the guests, satisfied, have closed their eyes, thanks to the camels...

Gabra song, Kenya

Camels in thorn enclosure, Kenya

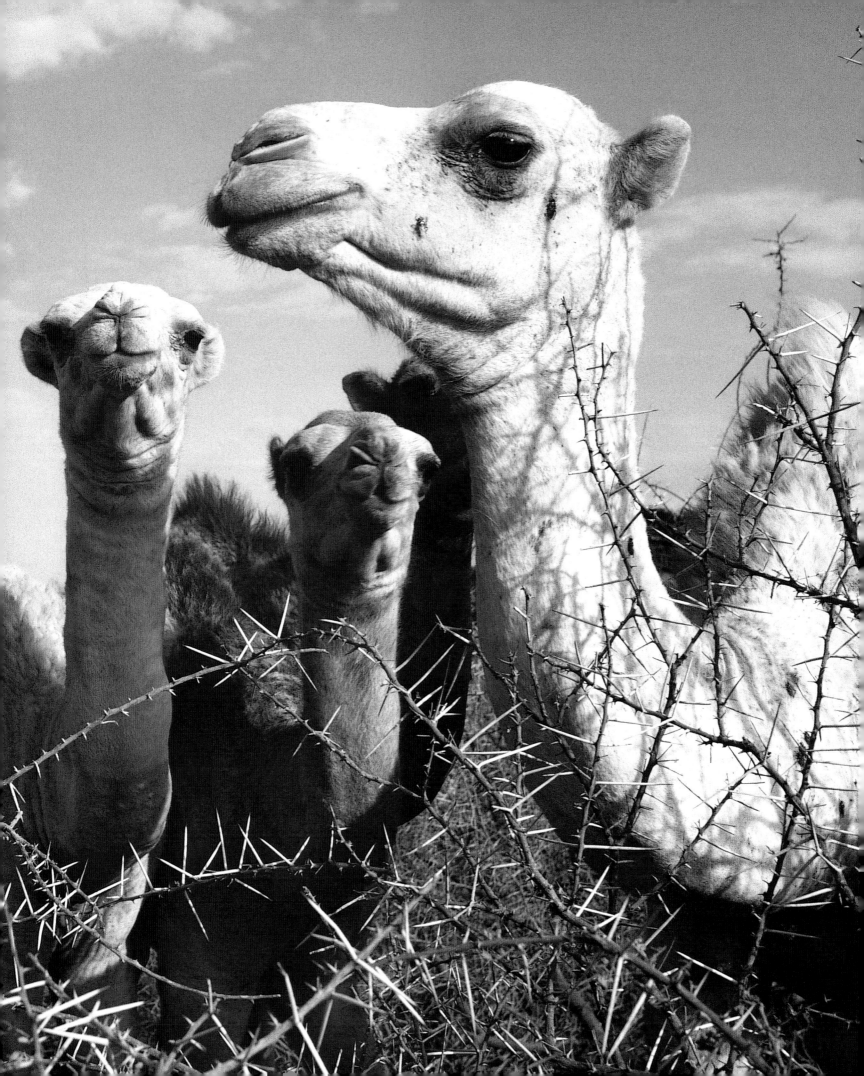

Some of the most spectacular ceremonies are conducted by Amazonian Indian groups. Mekranoti people, who paint their bodies in intricate patterns, perform various ceremonies throughout the year, some of them lasting for several months and involving much preparation and numerous treks into the forest to collect special foods. They keep parrots and other birds of brilliant plumage as pets, plucking them periodically, to craft stunning headdresses and body decorations with the feathers.

The corn festival is sustained over a period of months. In the most important phases the men wear headgear symbolizing the universe. The head piece, made of beeswax, is in the shape of the world. In the Mekranoti view the world is not round but composed of a central node representing the circular Mekranoti village – the center of the universe – from which are suspended protrusions depicting the beginning and end of the sky (east and west) and two arms (north and south). Mounted on a stick rising from the center is a vibrant feather arrangement portraying the upper level (the sky) from which Mekranoti people descended to earth. The stick represents the rope by which they made their descent. To be able to visit and return from the spirit world, Mekranoti shamans are said to change into birds.

The beautiful feathered headgear and costumes worn at the end of ceremonies in which individuals are believed to have undergone transformation are symbolic of the return of the participants to the community.

The importance of connection with the spirit world is shared by many nomadic groups. For Aboriginal people:

One of our great strengths lies in our ability to communicate with the spiritual world around us. This is manifested in our extensive use of symbolism, in our visionary experiences, in our Dreaming, and in our use of language. These forms of communication and these symbols have found clear expression in the creation of myths, the initiation ceremonies, the sacred sites and the healing rituals. They are evident in our oral literature.

Anne Pattel-Gray, Aboriginal, Australia

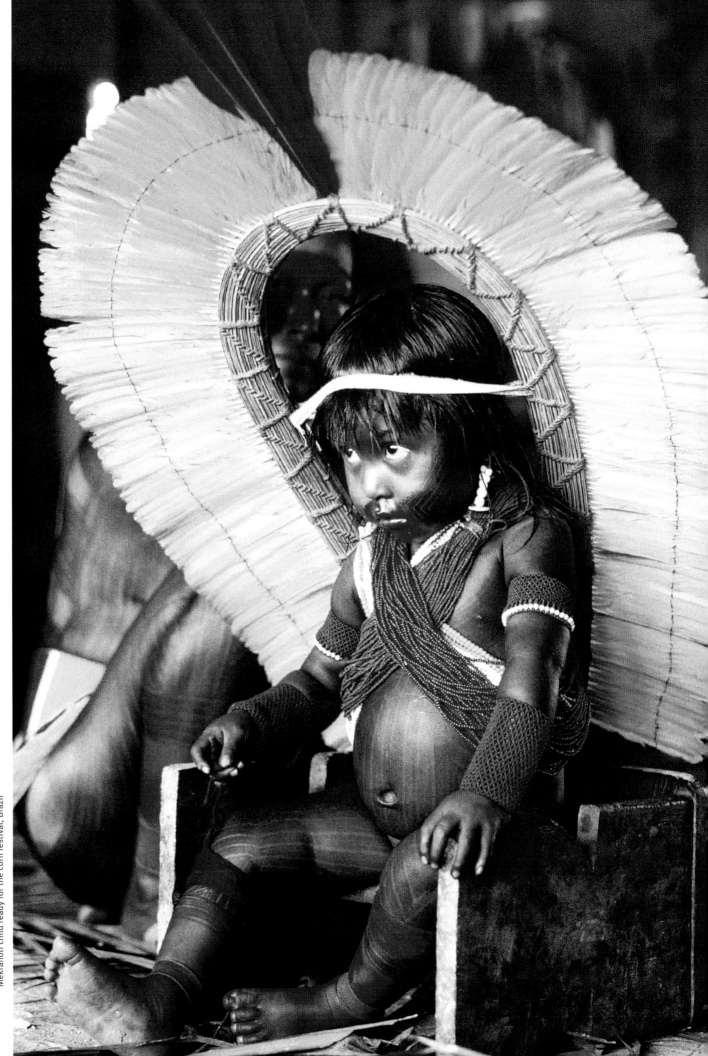

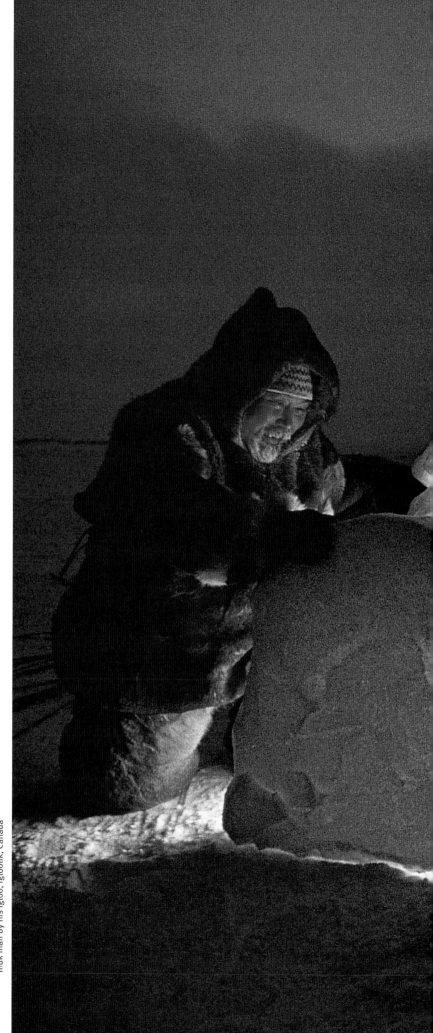

▌ Oqaluttuarpoq! Someone is telling a story! ...in the family igloo, people lie heads toward the center, feet toward the wall; their breathing becomes peaceful and takes on the rhythm of nighttime; two people, their heads close together, tell each other their secret thoughts in low voices. Their soft murmuring does not disturb the solitary man who is slowly sinking into a half dream. The soothing flame of the oil lamp is lowered. It is then that the mother begins to tell the story, slowly, in a low voice. Everyone listens in silence. The next morning, when the children wake up, they will ask questions about some details, and difficult sentences they will repeat several times. Someone will correct them. And that is all: they will remember the story forever. ▌

Jean Malaurie, Last Kings of Thule

Inuk man by his igloo, Igloolik, Canada

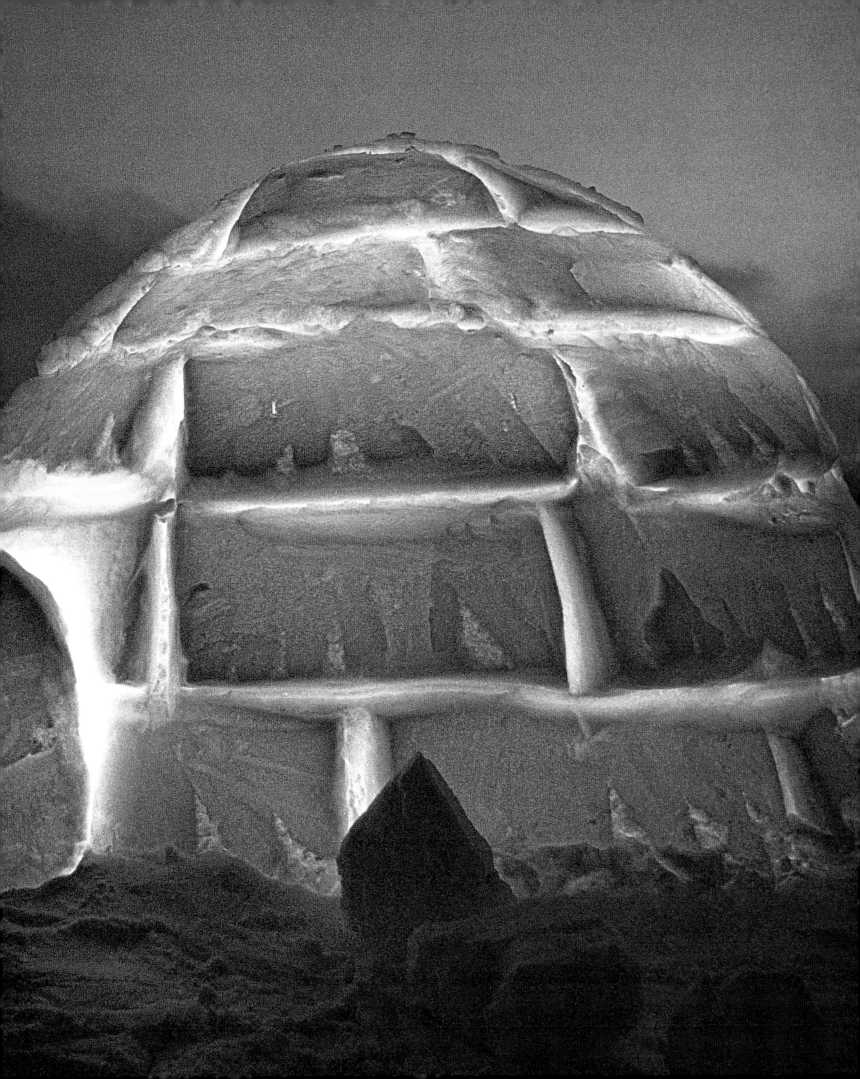

Perhaps storytelling above all is an experience of being together. The telling of the story draws people into an intimate, equal relationship with each other – women, men, children, old people. It links them to the generations that have sat in the same kinds of primal circles listening to the same stories before them.

From the beginning of her life, no one censors or limits the stories the little Inuit child hears.

▌ Her ability to make sense of what she hears is the only constraint. Her grandfather may give the details of the creation of sea mammals, at the earliest time of the world in which Inuit now hunt, with all its sexual and bloody details. He may tell a comic story about jealousy and fear. The small child listens for as long as she wishes... And she discovers that stories are always a mystery, for they have much that cannot be understood, and much that comes from knowledge and experience beyond understanding. There are words she knows, things she can make sense of; and these are both the broad and the small gateways to an immense edifice of facts that she may not understand in any full way, but that creates questions, wonder and puzzlement. ▐

Hugh Brody, The Other Side of Eden

Back in the 1880s, a San person – Kabbo – from the Cape region of South Africa was serving a sentence of hard labor for stealing a sheep after colonists with guns and horses had wiped out the game he once hunted. He imagined his people reaching out to him through their stories:

*T*here I will hear the stories that we love to tell. The plains people, my people, will be listening there to the stories that come from far beyond the plains. They listen to them, tell them, so that I who have to wait sitting in this sun, might hear them come to me – these stories like the wind, coming through the air. Already I feel them floating, while I await the moon, because the sun grows colder now, the autumn is upon us. And I know it, feel it, that I must soon return to be there with my fellow-men, talking with my friends.

Kabbo, San, southern Africa

Bedouin men greeting each other, Sinai, Egypt

People with an oral tradition admire those who have a way with words. A Beduoin saying holds that only three occasions merit congratulations: the birth of a son, the foaling of a mare and the emergence of a new bard. Today's Bedouin are still in love with words. They often break into spontaneous poetry at no greater provocation than discovering a good grazing patch.

The beauty of a man lies in the eloquence of his tongue.

Bedouin maxim

For Tuva people in Mongolia, words are also important:

Words are precious, they are not wasted. Words do not refer to something hidden behind them. Words work directly, have a powerful effect, a magic. They are understood as completely material, like slingstones or firewood.

Our people have a deep relationship with language, as they do with all things. And for that reason there is no such thing as an ugly word. Every word is good enough in its right place.

Galsan Tchinag, Tuva, Russia/Mongolia

Storytellers are often also skilful and amusing performers, miming the animals and characters, acting out the events they refer to and breaking into song; some may accompany the story with a drum. Baka pygmy storytellers in Cameroon intersperse narrative with song, eliciting at the appearance of certain story characters sung responses from the children around a fire in the forest at night.

In societies with no written language, storytelling is a daily event – one of the main ways in which people pass on to each other what they most need to know and affirm the world that they believe in.

Recurring themes in stories reflect what people believe to be of value. Prominent among these themes are sharing resources and the social calamity of greed. A group of Aboriginals, one story goes, were living up a mountain surrounded by a barren landscape in 'the first time' before the world was formed. Life on the mountain was good except that drought had nearly dried up all the water sources. All but one of the wells was empty:

▌Weeri and Walawidbit decided to steal the last of the water for themselves. Secretly, they made a large container. While everyone slept, they filled it and stole off into the night. When the theft was discovered next morning warriors set off in pursuit of the pair who could be seen bearing their heavy burden across the desert.

The best spearmen threw all the spears they had at the men. One hit the water container and fell to the ground. Unnoticed by Weeri and Walawidbit the container began to leak. By the time the warriors caught up with them most of the water was lost. The elders of the tribe decided to punish the two for their greed. The group's wise man turned Weeri into the very first emu and he ran off to the plains in shame. Transformed into the very first blue-tongued lizard, Walawidbit crawled away to hide in the rocks.

Meanwhile, wherever the water had leaked on to the plains, beautiful billabongs, or waterholes appeared, followed by grass and flowers and lovely water lilies and then by shrubs and trees. Soon, the birds came and there was enough water for everyone. ▌

Inscription, The Australian Museum, Sydney

Individuals depend on their groups for their survival. Sharing, at the heart of social life, is one of the key ways to keep the group together. To be a sharer one also has to learn to be a contributor. The twinned roles are learned early.

Nisa relates how as a young child in southern Africa she was out foraging with her mother when she spotted a dead baby wildebeest. She ran to fetch others to help carry it home but her impulse was not to share the carcass:

They skinned the animal; cut the meat into strips and carried it on branches back to the village. After we came home with the meat, my parents started to give presents to everyone. But I didn't want any of it given away. I cried, 'I was the one who saw it!'

People said, 'Oh! This child! Isn't she going to share what she has?' Later, I went to play. While I was away, mother took the meat and shared it with everyone. When I came back, all the meat had gone.

Nisa, !Kung San, southern Africa

Children soon learn the lesson. Just as adults share meat from a hunt, young children out hunting together will meticulously share the smallest catch, even to the point where no one ends up with anything.

Among Huaoranis in Ecuador, the child's first efforts to collect and share food is rewarded with parental pride above all else:

▌Nothing is more cheering for a Huaorani parent than a three-year-old's decision to join a food-gathering expedition. Young children, whose steps on the path are carefully guided away from thorns and crawling insects, are praised for carrying their own *oto* (a basket made of a single palm leaf hurriedly woven on the way), and bringing it back to the long house filled with forest food to 'give away', to share with others. ▌

Laura Rival, 'Blowpipes and Spears'

Groups get their food in different ways. Mekranoti hunt individually, while when Mbuti use nets to hunt in the Congo rainforest it is a group effort – men, women and children may be involved. San hunters may track in groups but hunt alone. If a hunter kills a large animal, like an antelope, he will go and call others to help him carry the meat home. However it is caught, meat is almost always shared.

Some nomadic people share to gain special recognition or to meet the expectations of the god they believe in. Among animal herders – where there is a greater personal wealth in the form of livestock – sharing is associated with attaining a reputation for generosity or gaining social standing.

Billabong (waterhole) in the Australian outback

For Harasiis Bedouin in Oman, a family's reputation rests on its generosity and a generous man is also more likely to get financial credit from settled Bedouin. Material wealth is valued, among other reasons, because it enables a family to be hospitable to travelers and visitors, for example by using their livestock to entertain visitors with fresh meat. In this way camel and goat herds are more than economic assets; they also symbolize a family's moral standing.

In Syria, among some Rwala Bedouin, an exchange relationship of mutual benefit exists between sheikh families and traveling gypsies (Nawar). The gypsies get safe passage and hospitality. In return they bring pots and pans, cotton cloth, woven goat hair for tents, medicine and dyes to trade. They also bring news and help spread the good reputations of Bedouin sheikh families whose generosity they experience.

Sharing is also an important part of life for the Somali herding nomads in East Africa.

When other families were around we always shared whatever we had. If one of us had some food – dates or roots – or maybe killed an animal for meat, we'd cook it and divide the meal among us. We shared our good fortune, because even though we were isolated most of the time, we were still part of a larger community.

Waris Dirie, Somali, East Africa

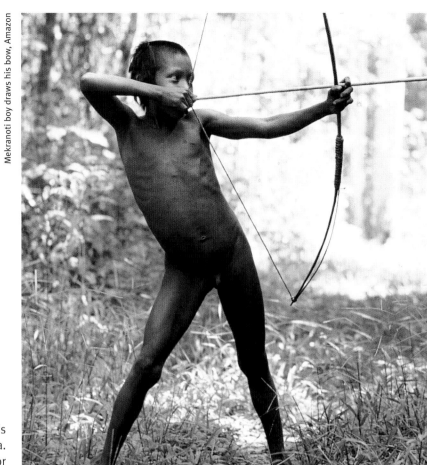

Mekranoti boy draws his bow, Amazon

Not all that far away from Somalia, Rendille nomads are the Gabra's near neighbors in East Africa. Sharing takes on another shade of meaning for Rendille people. Their god despises meanness. It is an honor to oblige a fellow tribesman who asks for the loan of a heifer camel and the idea of profiting from such a loan is alien. Ironically, a rich stockholder may find himself surrounded by cattle that he owns but has no profit from because they are on loan to people who own less stock than he does.

Like other groups where sharing is practiced as a matter of course, Huaoranis in Ecuador's rainforest have no equivalent terms for the phrase 'thank you', nor do they have the words, 'give', 'receive' or 'owe'. The way to describe something changing hands is to say it went from this person to that. They regard feeding others in their groups like feeding themselves:

*T*oday I killed a monkey;
Three darts tipped with poison.
I brought it to the People.
We ate and sang.

Huaorani song, Ecuador

This free giving of food to others in their group reflects the relationships Huaoranis believe they have with their forest. Like Penan people, before their forest was destroyed by logging, Huaorani groups inhabit surroundings they regard as 'giving'. That is to say, given their knowledge, their skills as hunters and gatherers, their enriching of the forest by moving and their few demands, their environment continuously meets all their needs. They come together not as producers but as consumers and celebrants of the sustained abundance of the forest.

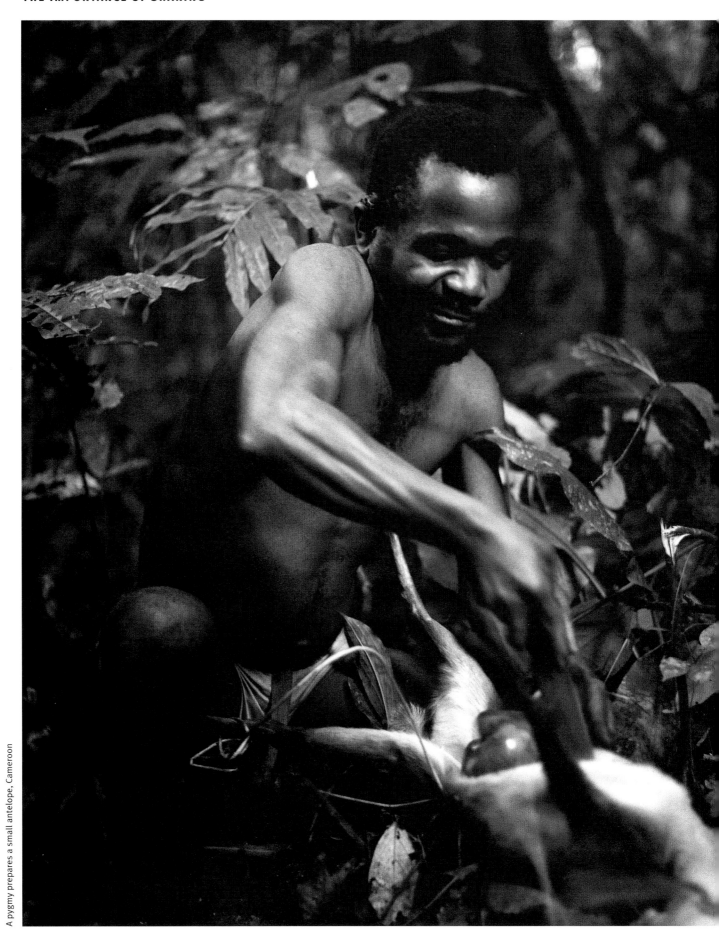

A pygmy prepares a small antelope, Cameroon

Bands of foraging and hunting people are strongly egalitarian and democratic, affording men, women and children a high degree of personal autonomy. Formal leadership tends to be confined to ritual activities and ceremonies, leaving people to make their own everyday decisions. Even where there are chiefs, as with some Amazonian Indians, it is their skill in interpreting consensus, ability to resolve conflicts and advocate wisely, and depth of knowledge of their culture that get them chosen to lead.

❚ Mekranoti leaders cannot command. If they try to impose their own desires on the community, they'll be abandoned or killed as happened a few times earlier in the 20th century. Chiefs must rely on their skill as orators to persuade others. During their speeches, they in fact articulate the consensus that is already growing within their groups. ❚

Gustaaf Verswijver, Mekranoti

In these bands generally no-one is in authority over anyone else and there is greater equality between women and men and young and old. Huaoranis believe that nobody should be made to do something they don't want to do. Individuals should only take action because they want to. Indeed, it would be socially harmful to induce people to act against their will.

Huaorani people live in open long houses, shared spaces in which everything goes on – cooking, the making of crafts, chanting, procreation and the upbringing of children. Adults have no particular sense of themselves as being superior to children and are not overly protective. In most bands children are not set apart from any aspect of life. They learn by accompanying, watching and doing. They receive strong encouragement as soon as they show signs of independence or wanting to try their hand as something.

My mother wove beautiful baskets, a skill that takes years of practice to achieve. We spent many hours together as she taught me how to make a small woven cup that I could drink milk from.

Waris Dirie, Somali, East Africa

Huaorani house, Ecuador

For Inuits of Alaska a sense of equality across generations is underpinned by the belief that the spirit of a dead grandparent chooses to be reincarnated in a grandchild, who is then named after him or her. This means that a child is doubly loved – both on his or her own account and, in the case of a girl child, on her grandmother's. She must be respected as her grandmother was. She is given the choicest morsels of food and not told to sleep when she wants to be awake. Betty tried to understand how her grandmother's spirit entered her:

I think I know how I got to meet my grandmother. She was being carried away by the wind and suddenly the wind stopped. Everything was still. Then I was born, and she had the chance to breathe her breath into me, and then the wind came up again and she was gone.

Betty, Inuit, Alaska

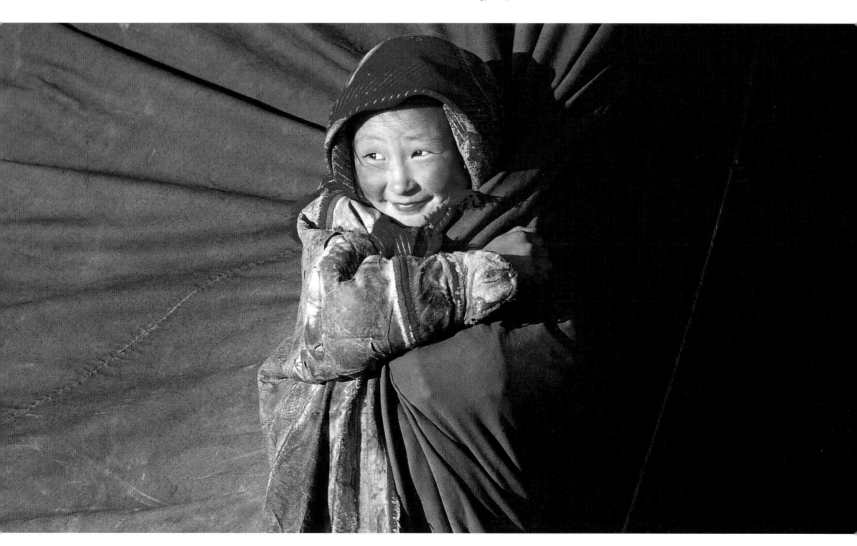

As the little girl learns to be with her friends in the community of children who roam on the tundra, play on the sea ice, share chores in one another's homes or sit listening to the talk of adults, she notices the way in which individual choice is respected and independence encouraged:

▍ Nedercook, who grew up in an Inuit village near Rockey Point in Alaska, demonstrated this individualism and independence when at the age of 10 she decided to go out hunting on her own with a bow and arrow across the snow-covered tundra to a nearby creek. In soft snow, sheltered from the wind, she knew she could look for bird tracks.

She was surprised to find duck tracks since all but one kind of big black duck had long left. She could tell that the partly-drifted tracks were made when the duck first landed and reckoned it would need to rest because it would be tired from being blown inland from the open water. Tracks were lost in places where the snowdrift was harder but she pressed on.

At the third crest of hard snow as she was inching her head to peek over she saw the duck still in the sitting position where it had probably rested since it found this sheltered spot. Nedercook aimed her arrow. The bird had seen her. It was not alarmed, but started to raise itself. She described how she let the arrow fly and in her excitement tumbled into the deep snow. But she soon had the duck in her hands. When she was sure it was dead she sat in the snow. Happy. She whispered *'Quiana'*, thank you, as she examined the big black bird and anticipated praise for her success. ▍

Edna Wilder, Once Upon an Eskimo Time

In Africa, the !Kung San living in the Kalahari region and the Mbuti of the Ituri forest have been described as among the world's most egalitarian societies. Women's and men's work is complementary. In many groups both women and men make and decorate artifacts. Generally each is autonomous in their own realms of activity. More food is derived from foraging, women's work, than from hunting. But the return of men from the hunt was always an event for Nisa, when a girl:

Whenever my father brought back meat I'd greet him 'Ho, Daddy's coming home with meat!' And I felt thankful for everything and there was nothing that made my heart unhappy.

Nisa, !Kung San, southern Africa

On trek, it is usually women who build the shelters. Mekranoti people construct their villages in a circle, the doorways facing inwards, reflecting their communality. In the center of the circle is the biggest structure – the men's house. There, men hang out together, do expert grass and feather work, prepare for ceremonies, sing together and discuss matters of importance. Bachelors sleep there, as do married men during and after their wife's pregnancy.

East African animal-herding people are generally more hierarchical. Authority resides with the male elders. Over time every man moves through the age hierarchy and becomes eligible for ritual and political authority.

Due to a tiresome wind sweeping over the plains, Gabra houses in Kenya are arranged in a line with their backs to the weather and the openings all facing in the same direction. The line represents the age hierarchy with the youngest household head at one end and the most senior at the other. In practice the Gabra are among the more egalitarian of herding groups in Africa. Informal leaders emerge whom people follow on day-to-day issues. Often these leaders are not elders and sometimes they are women.

However, as pastoral people have become more involved in the cash economy and generally become poorer, women's authority has been eroded, as it has among farmers:

▍ They have tended to lose power both as milkers and in deciding what happens to milk once it is out of the teat. Among the Gabra and the Borana, a woman controlled the distribution of milk to family members and guests. No man could take down a milk pot and offer a visitor a drink. That was the wife's prerogative... Women and youths did most of the milking and so they also decided what milk was left for the calves and which animal was to be milked for human consumption. While both husband and wife were equally concerned to balance the welfare of the herd with that of the family, the woman had decision-making power. ▍

Paul Baxter, anthropologist

In the forest of central Africa, only one Mbuti song can be sung by a single singer. Hunting songs are broken up into separate notes, each note being assigned to one hunter.

▌ The melody cannot be made to sound unless all the hunters sing their individual notes, with precision and at exactly the right moment. The hunting song thus recreates the intensive cooperative patterns required by the hunt...

The only solo song is the lullaby, an intimate communication between a mother and her child, to be sung by her alone and composed specially for each child while it is yet in the womb. ▌

Colin Turnbull, The Forest People

Groups that have herds to care for have more tasks to undertake and so have to be more organized. In such groups there are clear divisions of responsibility assigned to men, women, boys and girls, but the responsibilities are carried out with freedom and individuality and with time for repose.

After we finished our chores, we'd have our supper of camel's milk. Then we'd gather wood for a big fire and sit around its warmth talking until we went to sleep.

Waris Dirie, Somali, East Africa

For Gabra people, there is a similar sense of repose after the labor:

▌ In each village there is a place which is rather like the physical symbol of the atmosphere of freedom and relaxation that is so characteristic of Gabra life; the place the Gabra call *gaassa*, the shade (no matter how sparse) of some tree or dry branches. In the long, hot afternoons, it is there that the men gather to rest, while the women are resting in the comfort of their houses, to chat, to play the endless pebble game, *saddeeqa*, or to carve the many fine wooden objects they make for their home. There in the shade they pass the hours exchanging news. ▌

Paul Tablino, The Gabra

It was once assumed that people in harsh environments spend all their time working to survive. In fact most of the activities are social as well. Even where hunting is solitary it is shared through the telling of the hunt and the sharing of meat. Being on the move, setting up and dismantling camp, constructing new villages, cultivating (for those who do it) and preparing food are all highly cooperative, sociable and often festive, occasions.

Nomadic craftspeople take pleasure and pride in making the things they use, investing care and creativity far beyond the economic value of their artifacts. The Huoarani sign the things they make. This investment is often abandoned when tribes start making crafts for the tourist market. In most groups that hunt and forage for their food, activities that might be defined as economic account for only a few hours a day. Time is given over generously to purely sociable, meditative, ceremonial and leisure activities.

▌ The Huaorani term, *huentey,* describes 'the state of perfect stillness and tranquility felt by, and flowing from someone lying chanting gently in a hammock'. Schoolteachers and missionaries have wrongly translated the term as 'laziness'. The Huaorani believe that *huentey* prevents tensions, bad feelings and the risks of a group breaking up. It restores harmony in the long house. ▌

Laura Rival, 'Prey at the Center'

Like storytelling, in most groups singing together is a daily event. People sing for pleasure and in ceremonial activities expressing the unity of the group. The importance of song is passed from generation to generation:

I am an old man.
I know many songs,
Now you must learn to sing,
You young men,
You Huaorani,
You strong, young Huaorani.

Huaorani, Ecuador

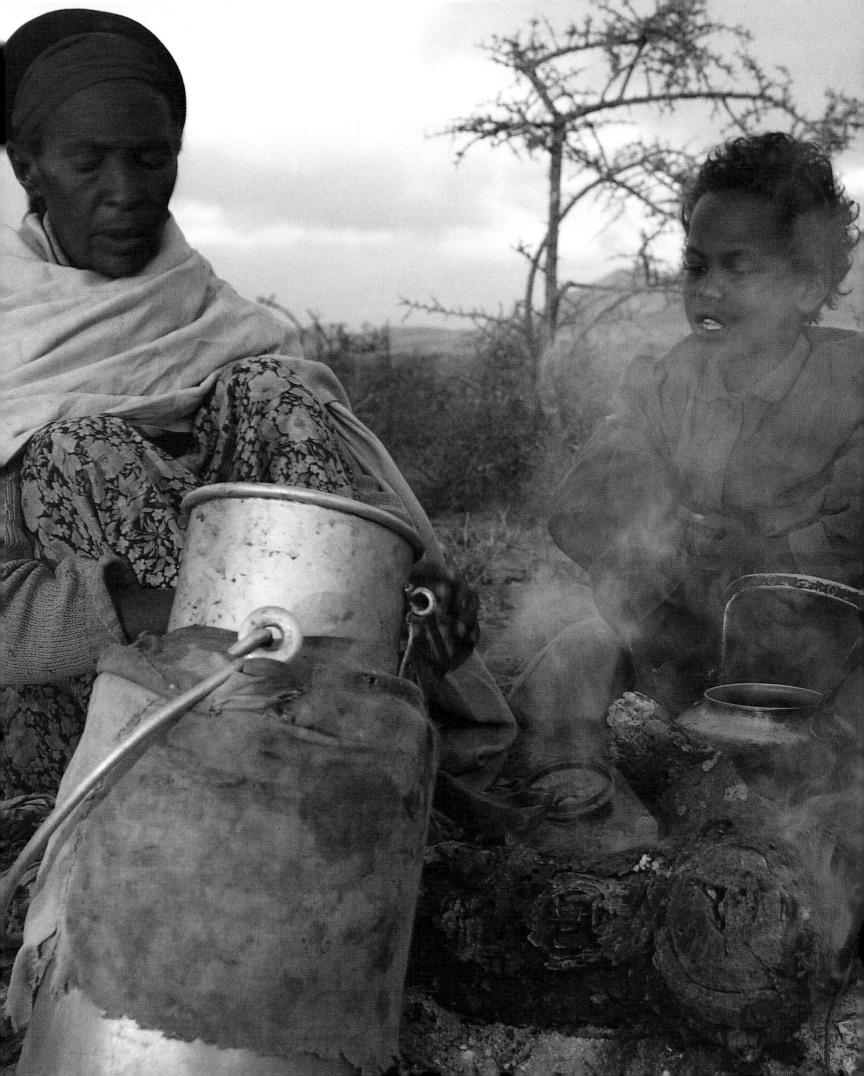

SETTLING ARGUMENTS

Among the greatest crises that can befall nomadic people is the splitting up of their group. When serious quarrels occur, as they do in most groups, communities rally quickly to resolve them. A remarkable feature of Mbuti life is:

▌ The way everything settles itself with apparent lack of organization. Cooperation is the key to pygmy society; you can expect it and you can demand it and you have to give it.

If your wife nags you at night so that you cannot sleep you merely have to raise your voice and call on your friends and relatives to help you. Your wife will do the same, so whether you like it or not the whole camp becomes involved. It is at this point that someone, very often an older man or woman who has so many relatives and friends that he cannot be accused of being partisan, steps in with the familiar remark that everyone is making too much noise, or else he will divert the issue on to a totally different tack so that people forget the origin of the argument and give it up. ▌

Colin Turnbull, The Forest People

Where disagreements cannot be resolved immediately among nomadic people, the discordant parties may simply go off in different directions for a while, joining up again later. In extreme cases, a group may decide to split up.

Despite the harshness of their lives and lack of possessions, nomadic people and perhaps particularly hunting and foraging groups have an important hallmark of affluence: free time.

They are generally able to satisfy their needs from their surroundings in ways that leave them plenty of scope for leisure and recreation – much more time than people in agricultural or industrial societies. This is true of those living in the relative abundance of the rainforest and those in leaner environments that can only be considered hospitable by people who know them intimately.

More remarkably perhaps, nomadic people have found ways to live in which positive human qualities of cooperation, generosity, hospitality and concern for one another are – at least within their groups – reinforced not as being morally desirable but because they are crucial to survival.

'Fire Dreaming', by Yuendumu Aboriginal women, South Australia

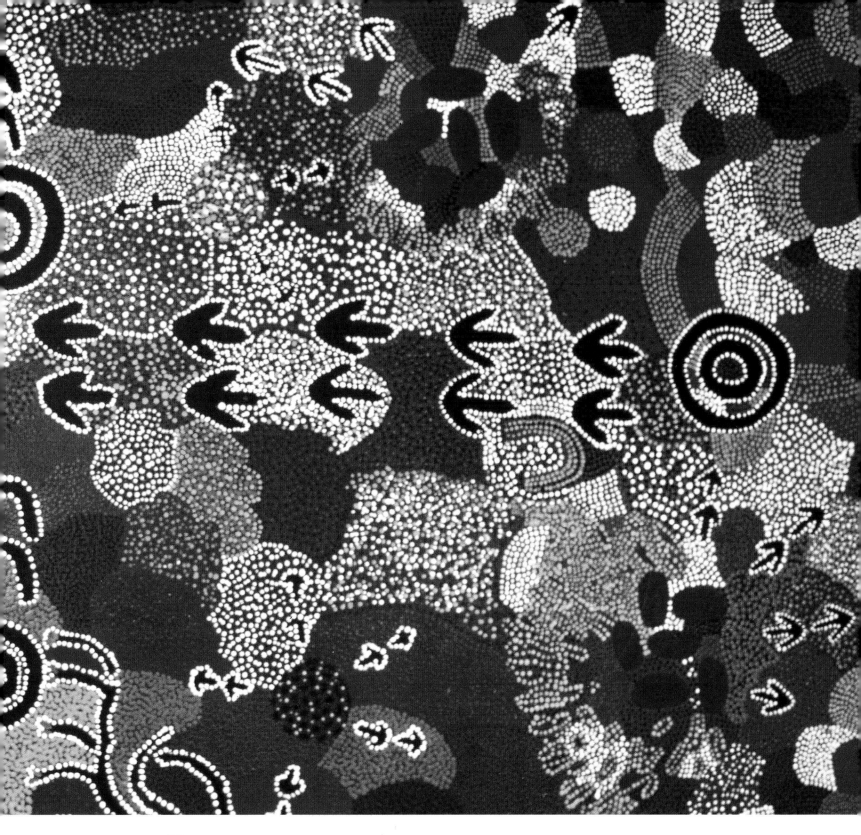

***T**hey say we have been here for 40,000 years, but it is much longer*
We have been here since time began
We have come directly out of the Dreamtime of our creative ancestors
We have kept the earth as it was on the first day.

Southern Arrernte Aboriginal group, Australia

Wind-swept plains, rolling sand dunes, scrubland full of stones. Dry lands that seem unwilling to yield their water. Empty vastness under a wide sky, dotted with the pale colors and shapes of animals, and the low domed homes hugging the earth. Often burned with fierce sun by day and bitterly cold at night, these extreme, harsh places are where most nomadic pastoralists live, moving with their herds of camels, cattle, sheep or goats in search of grazing and water. Occasional trees and bushes stand out with splashes of green, often a dusty green. But the stark lands are beautiful, too, with their soft colors of yellow, red, ochre, brown, gray and beige.

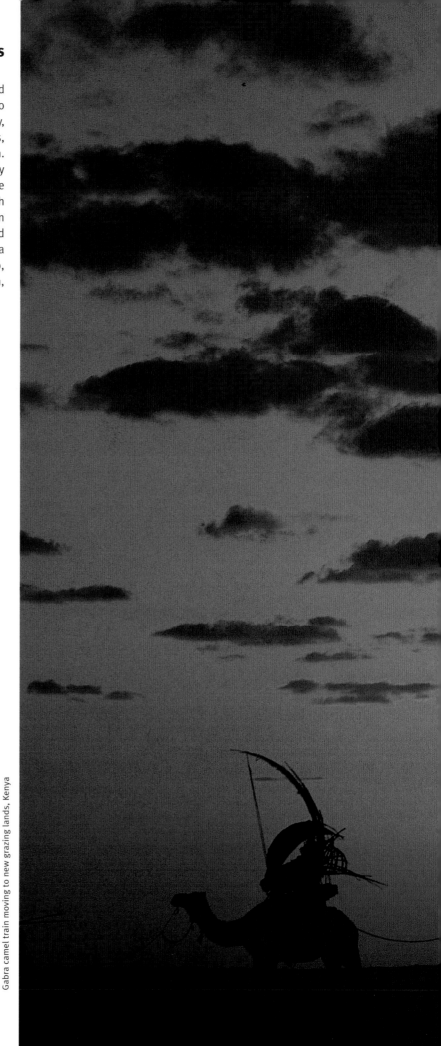

Gabra camel train moving to new grazing lands, Kenya

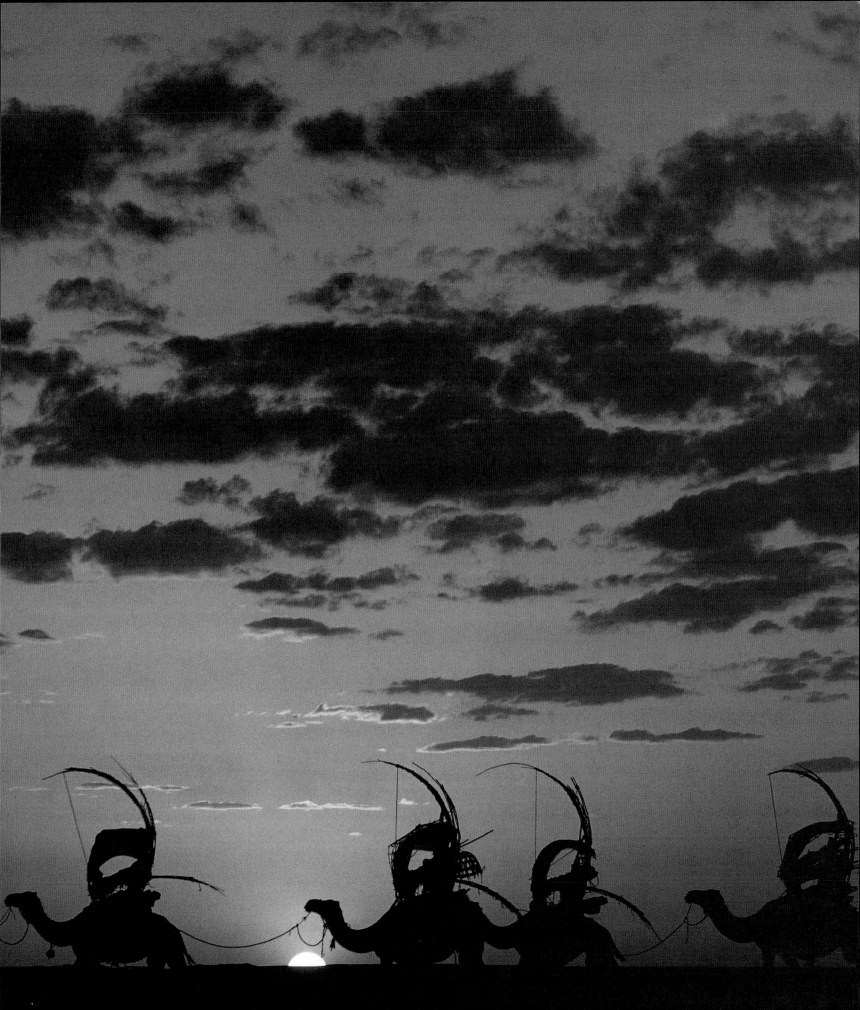

The teapot, an important part of Tuareg life and hospitality

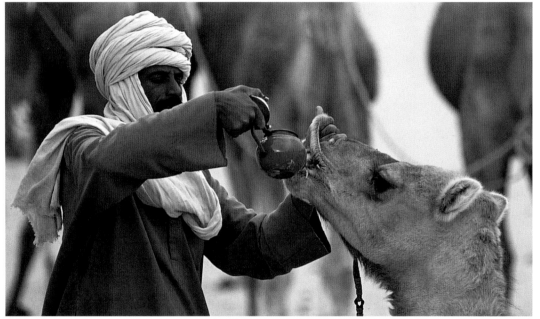

... especially for their camels

I enjoy my life. I like taking care of the camels. I would like to see if driving a car is different from riding a camel. I don't know the world. The world is where I am.

Ahmid, a 15-year-old Tuareg, Sahara

Tuareg with his camel, near Djanet, Algeria

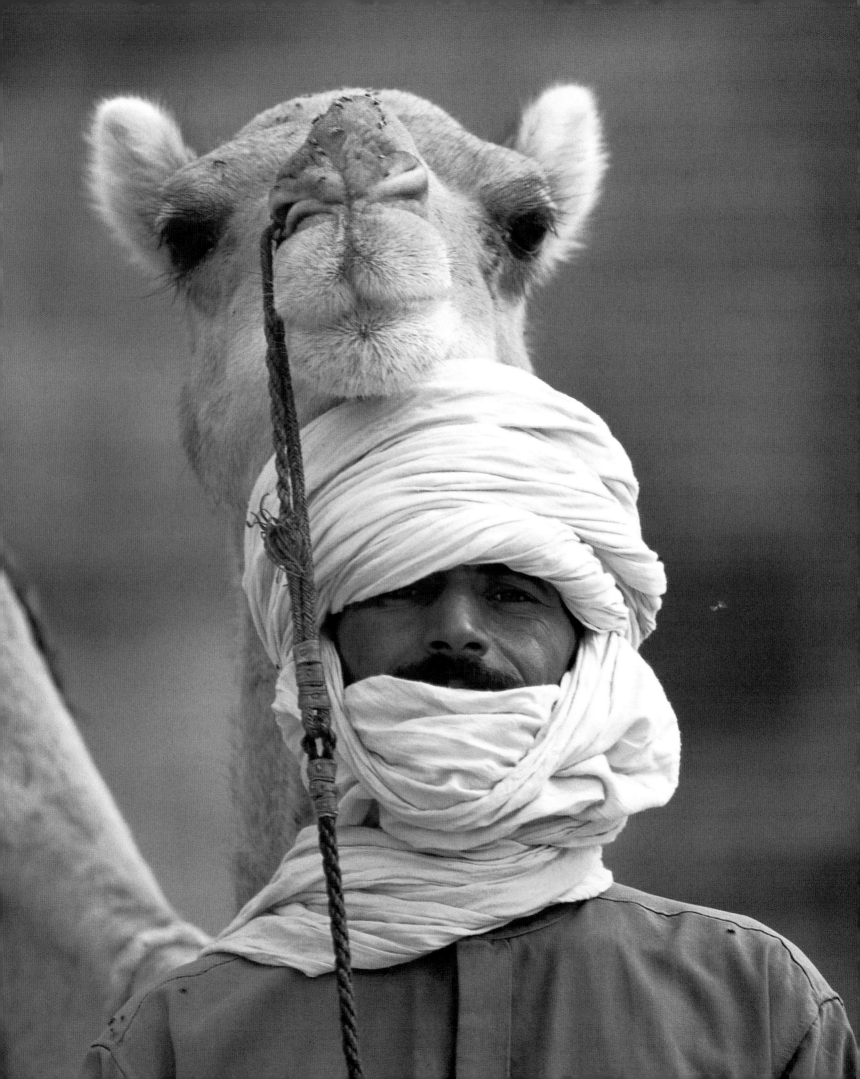

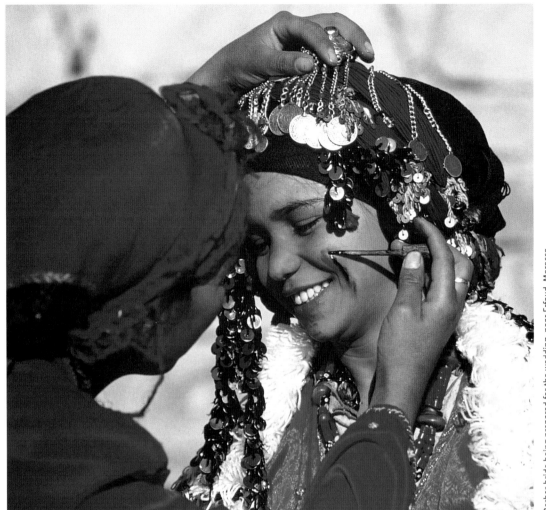

Berber bride being prepared for the wedding, near Erfoud, Morocco

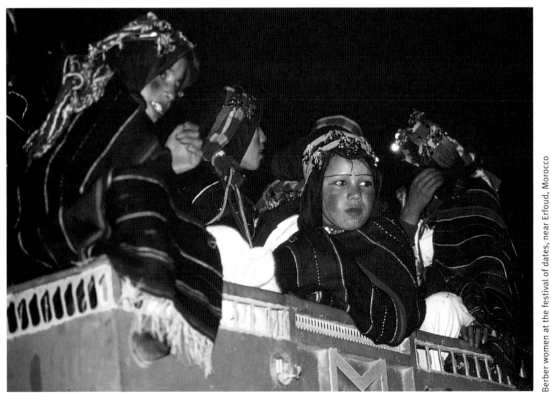

Berber women at the festival of dates, near Erfoud, Morocco

Rashaida wedding dancer, Eritrea

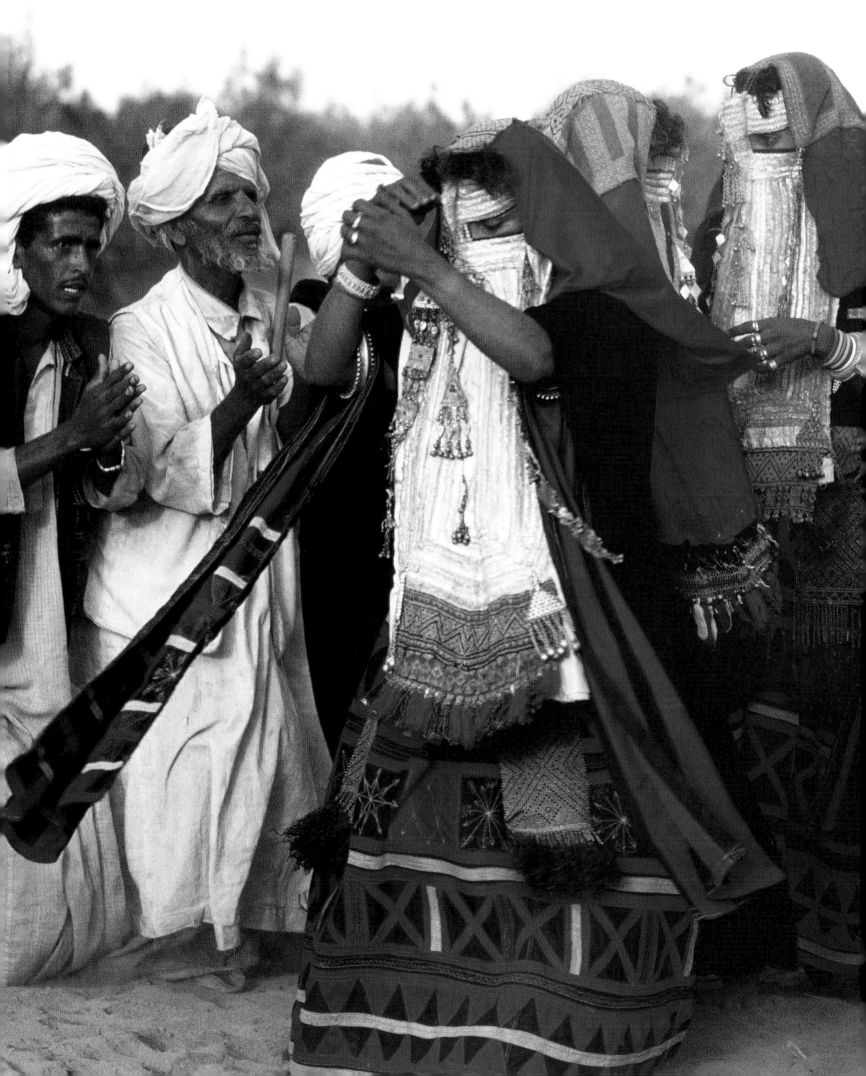

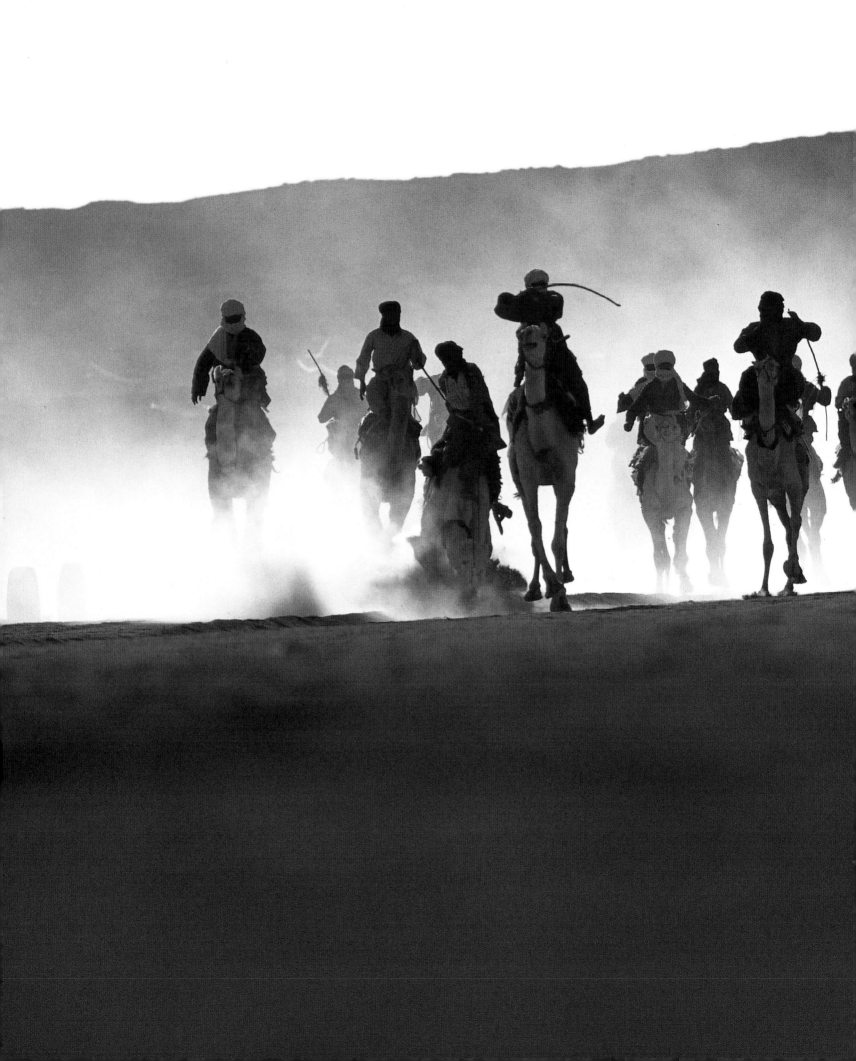

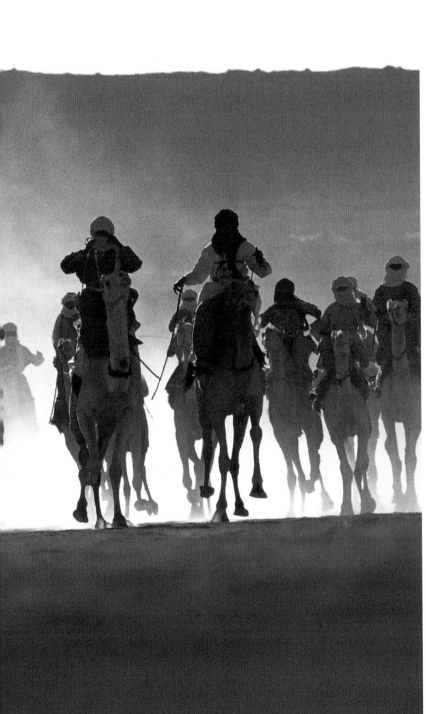

A she-camel is a mother
To the one who owns it
While a he-camel is the artery
Onto which hangs life itself.

Somali saying, East Africa

Tuareg mother carrying her daughter, Timia, Niger

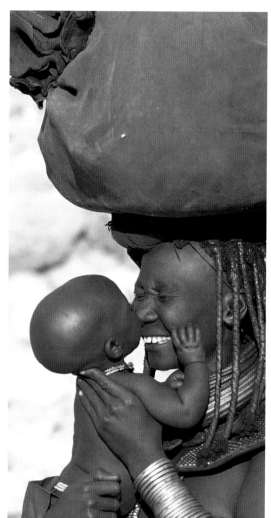

Himba mother and baby, Kaokoveld, near Opuwo, Namibia

Turkana woman carrying a fish, Kenya

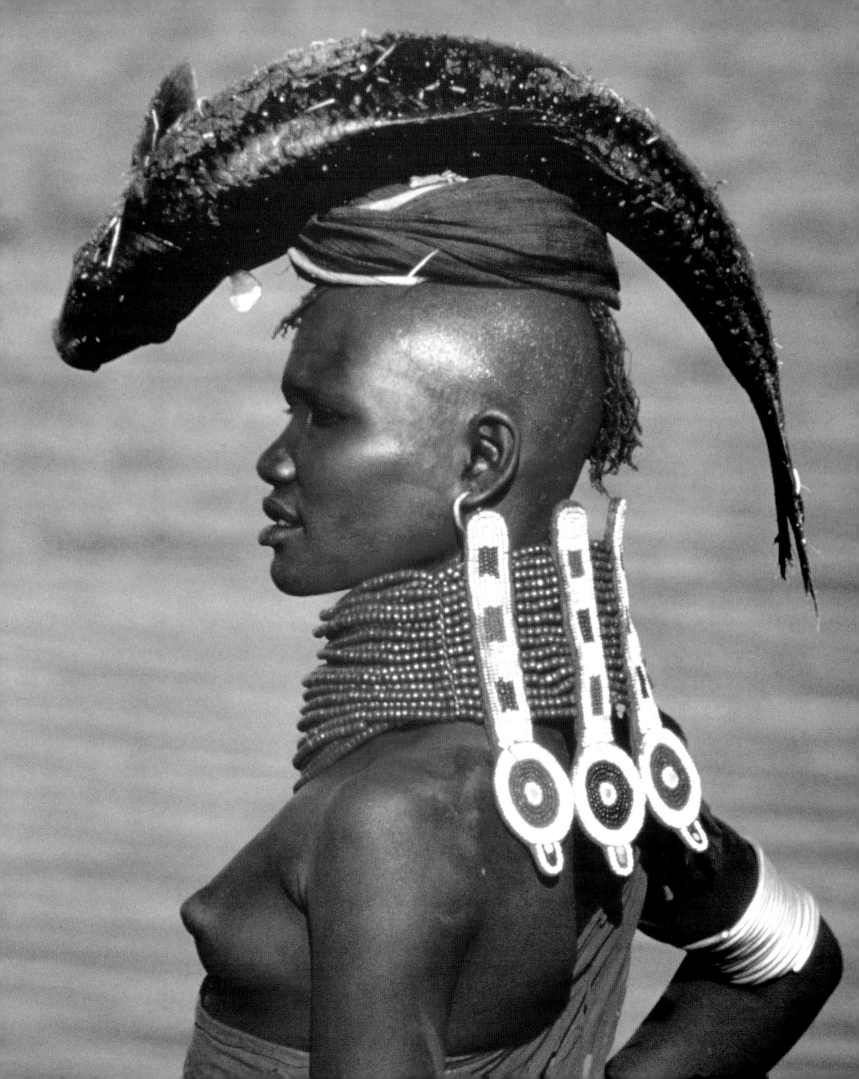

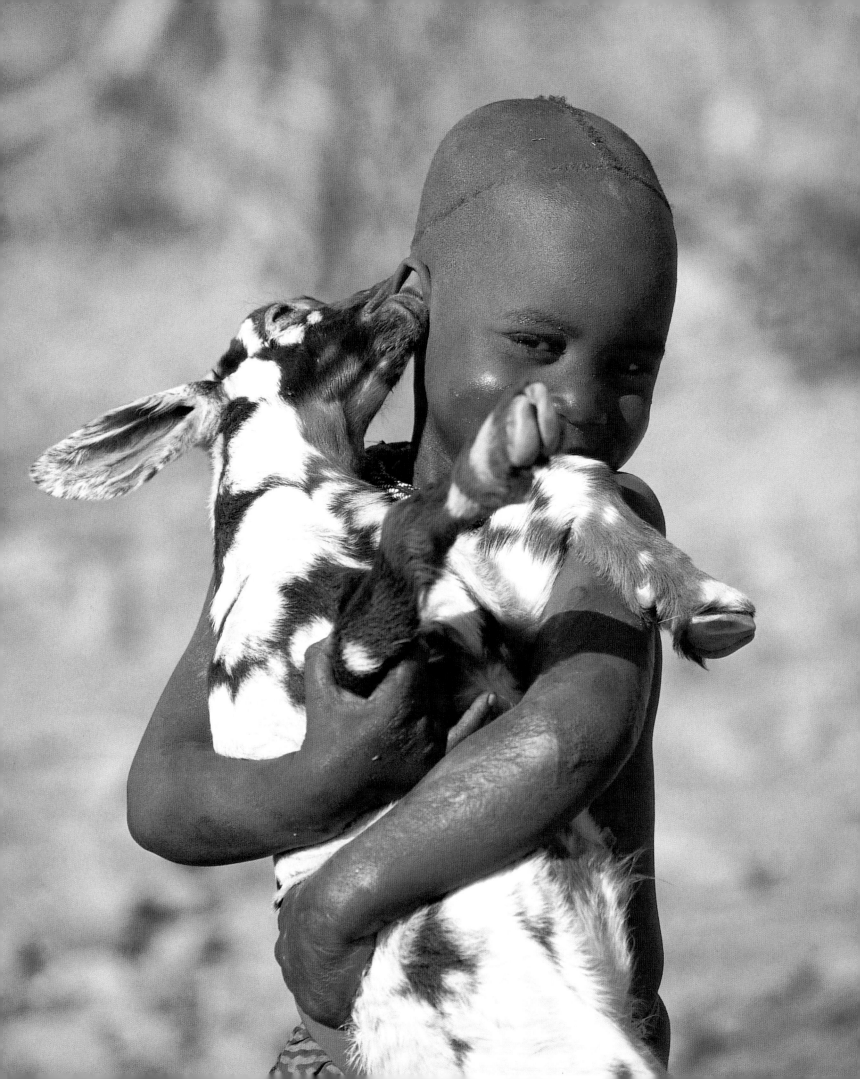

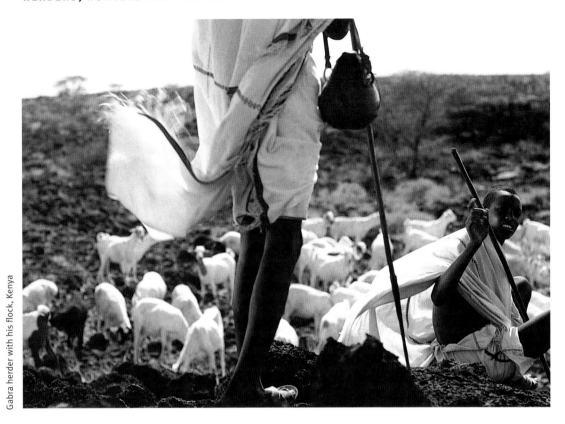

Gabra herder with his flock, Kenya

He has herded the beasts well.
We commend him!

Rendille, East Africa

Himba boy with goat, Namibia
p74/75, A sandstorm arrives, Gao, Mali

*T*he heat was killing us and we were all dying of thirst. I started to cry because I wanted water so badly. After a while, we sat down again in the shade of a baobab tree.

Nisa, !Kung San, southern Africa

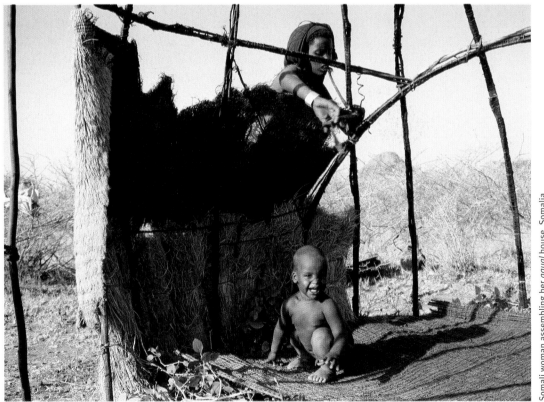

Somali woman assembling her *aqual* house, Somalia

Xama, a !Kung San woman in Botswana, collecting water

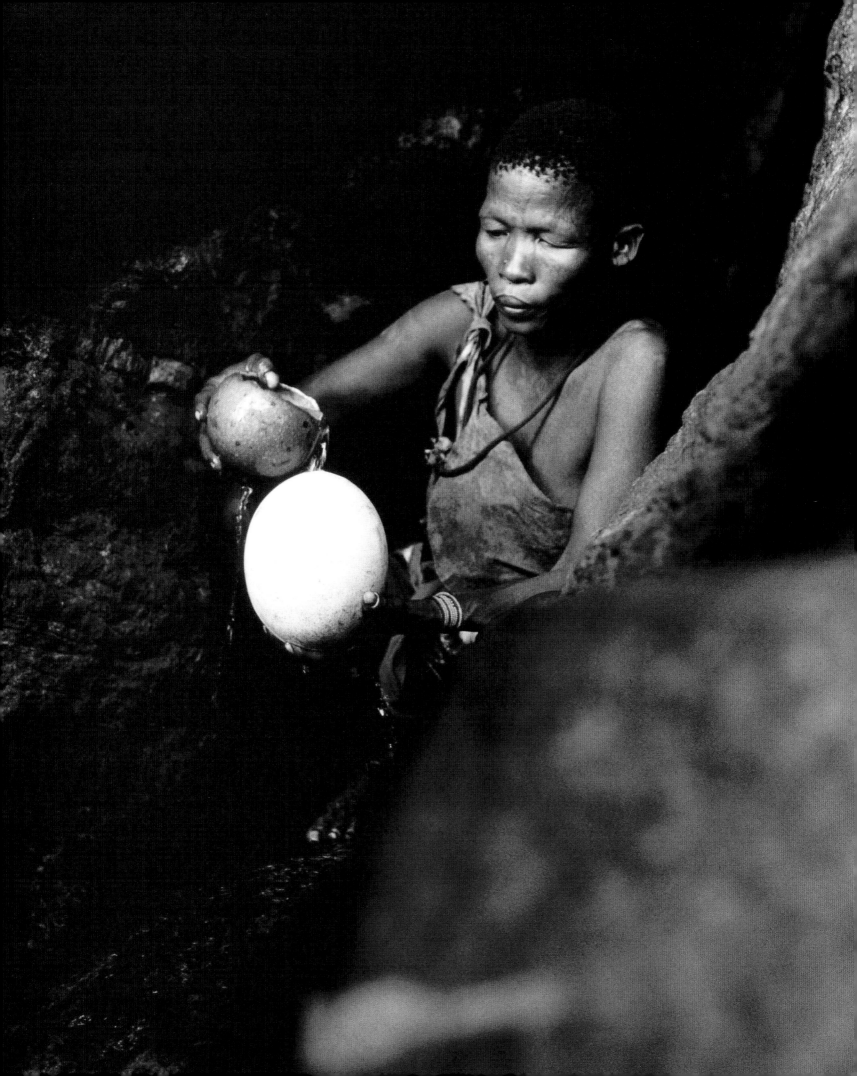

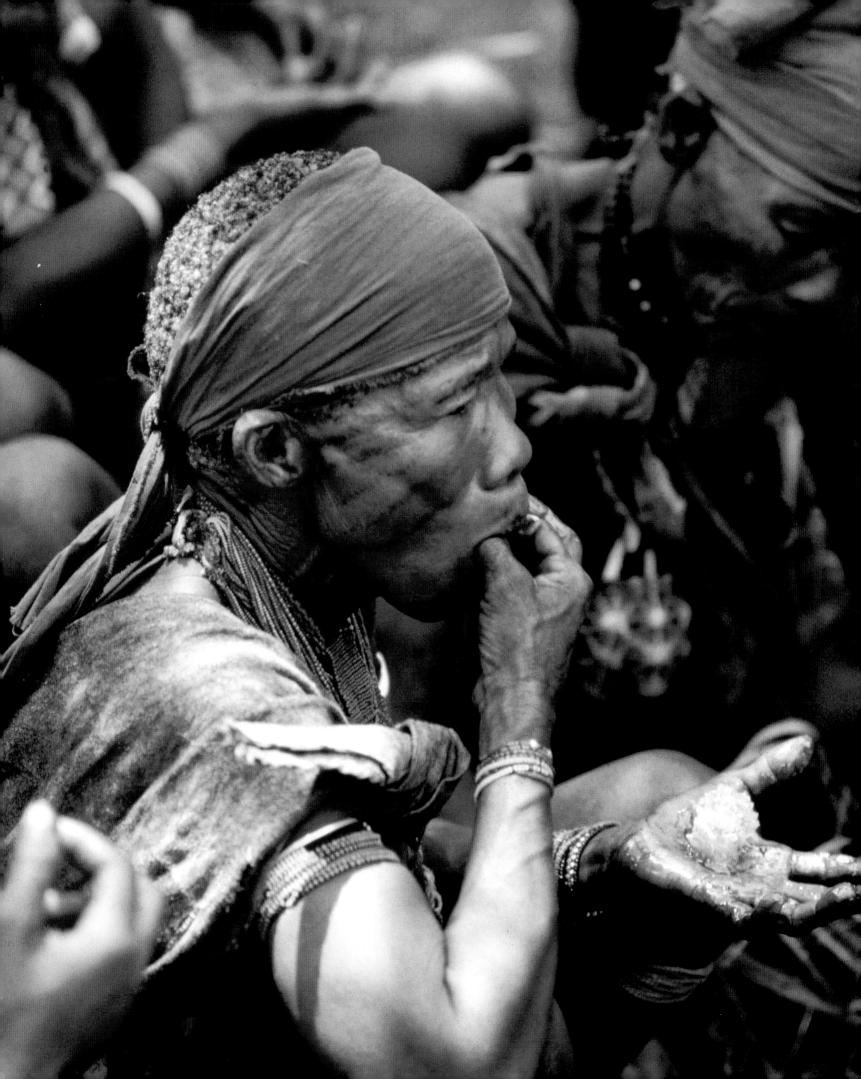

!Kung San women eating wild honey, southern Africa

***W*e had been walking a long time and then my older brother saw a beehive. We stopped while he and my father chopped open the tree. All of us helped collect the honey. I filled my own little container until it was completely full. We stayed there, eating the honey.**

Nisa, !Kung San, southern Africa

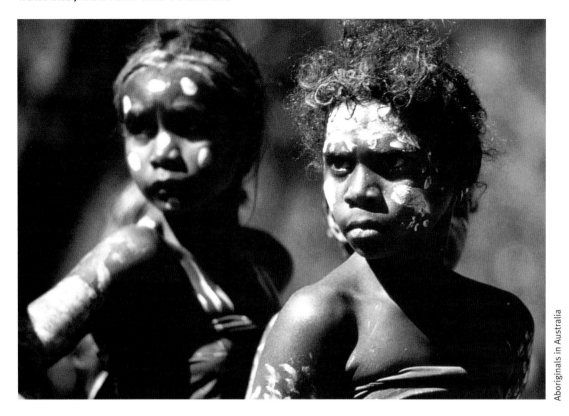

Aboriginals in Australia

*T*he feeling of our relationship to the earth is so strong that we feel parts of the land which belong to our Dreaming are like parts of our body. It is good for the skin to touch the earth, to walk with bare feet on the sacred earth.

Anne Pattel-Gray, Aboriginal, Australia

In the outback, Australia

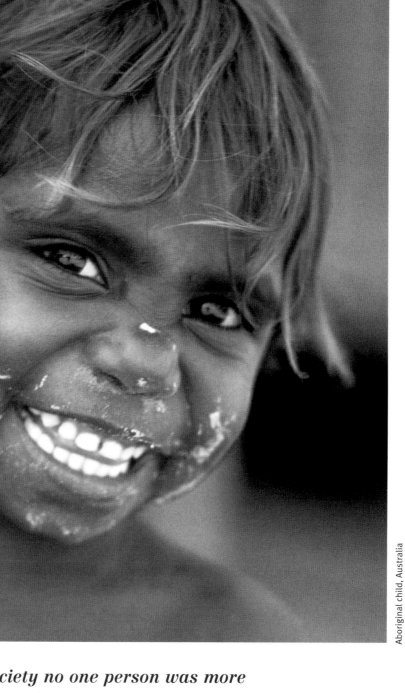

Aboriginal child, Australia

***I*n Aboriginal society no one person was more important than another – all were parts of a whole. Growth and stature were measured by contribution, participation and accountability.**

Pat Dodson, Aboriginal, Australia

Aboriginal man with body painting, Arnhemland, Australia

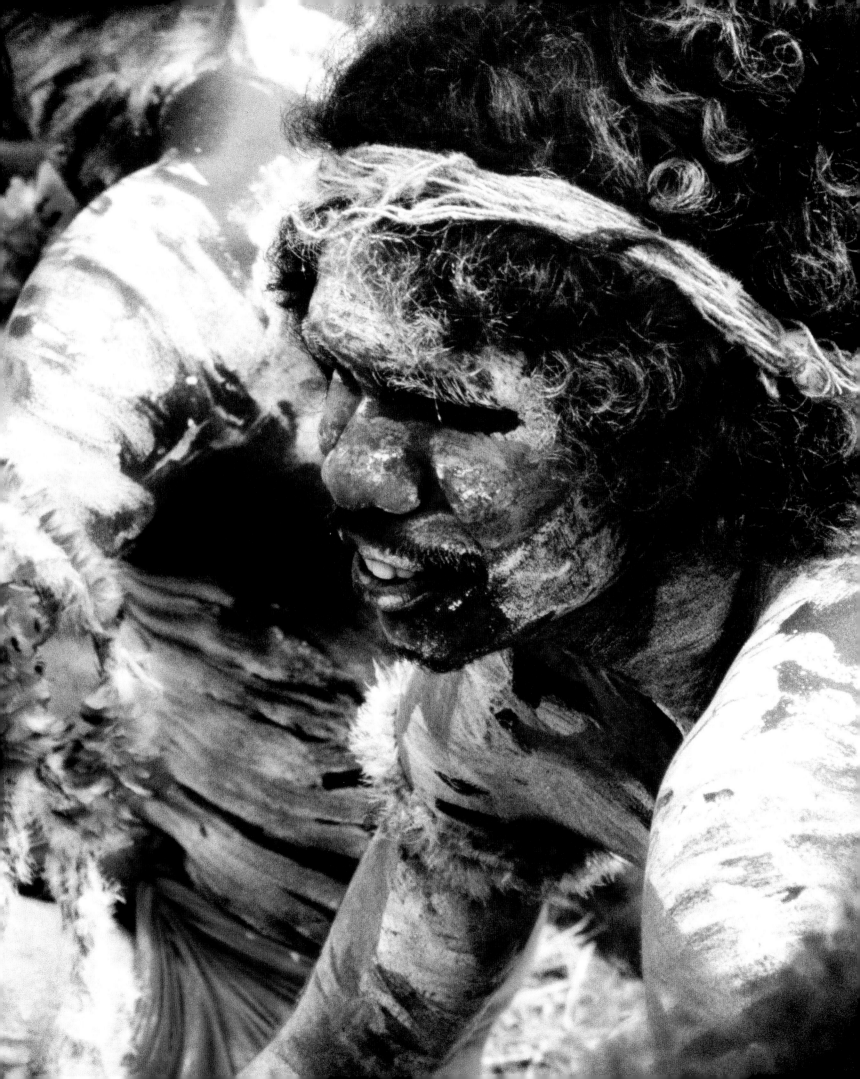

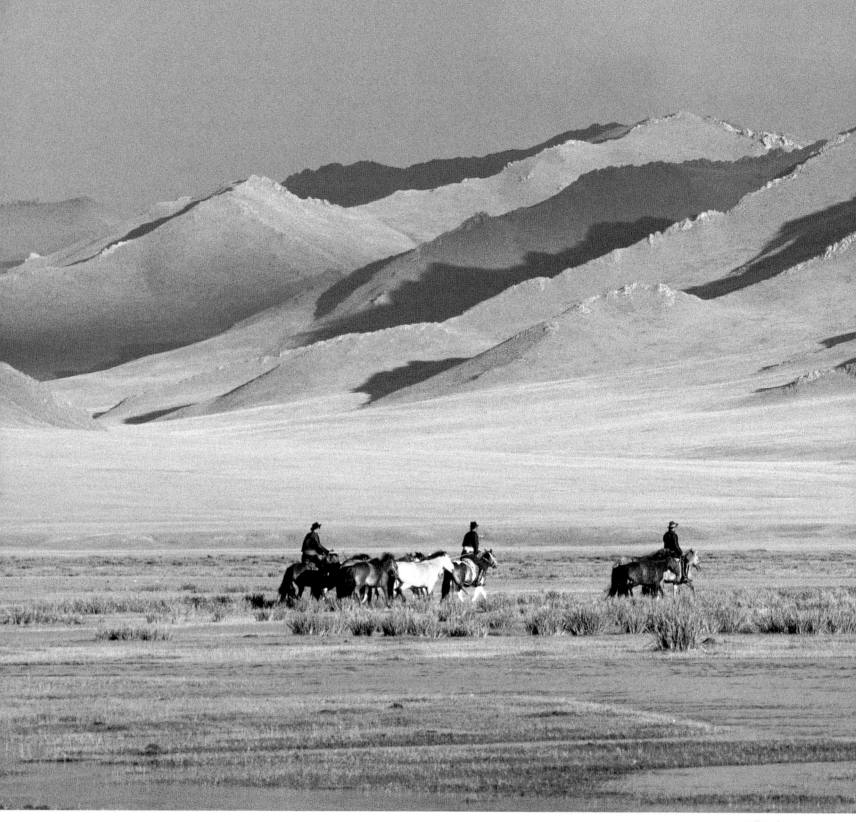

Valley of Dzag, Mongolia

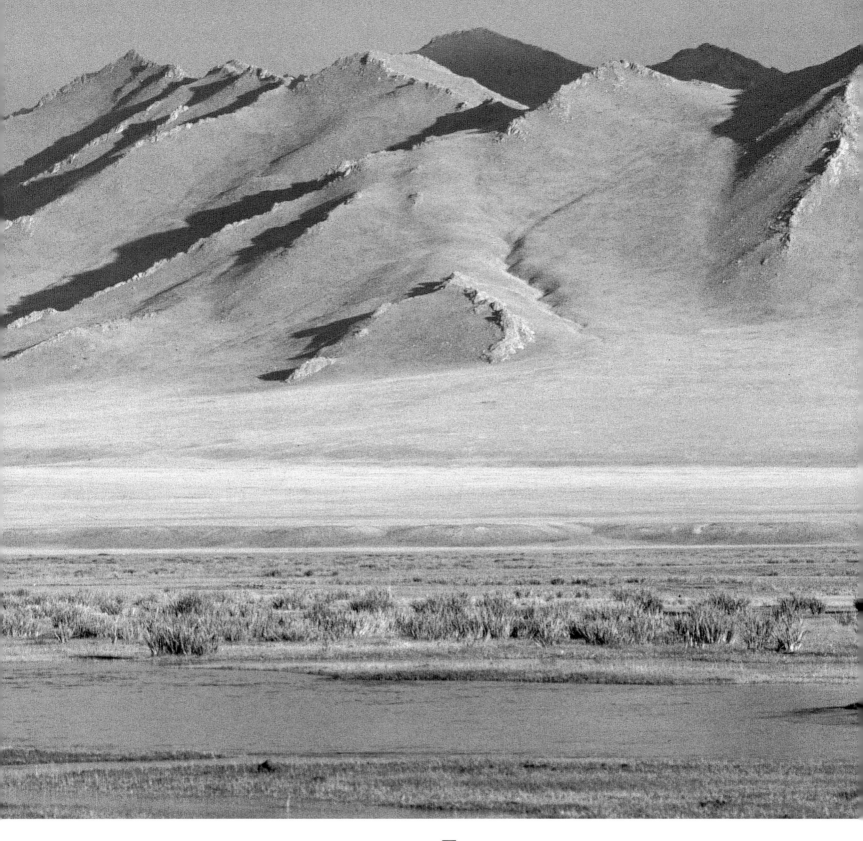

F*or three horse-lives
I have followed
The restless nomad herd...

*about 60 years

Galsan Tchinag, Tuva, Russia/Mongolia

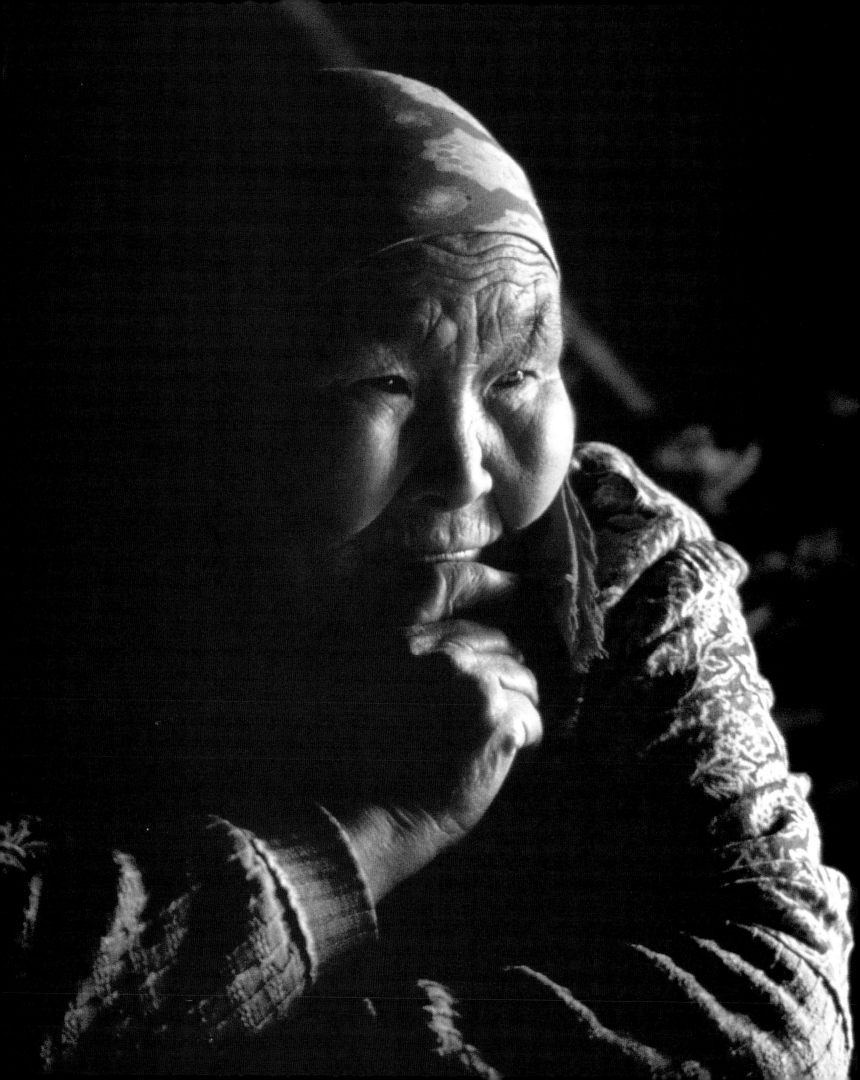

Tuva is so isolated from the world. We Tuvans, there are just a few of us in a small nationality. We live in such a beautiful place because our wise ancestors fought for and protected our land for us, we are the heirs of their wisdom and their struggle. Because of our ancestors' strong character and wisdom, they saved the land for us. It's a place so alive and rich with life, animals, fruits. Because of that we will continue to protect our land, our culture, our people, our history.

Kongar-ool Ondar, Tuvan throat singer, Russia/Mongolia

Evenki woman, Russia

Penan youth, Borneo

Rainforests are ancient places, pre-dating the dinosaurs, with some trees erupting 25 feet above the forest canopy. Inside, the sunlight is doubly filtered. The canopy is formed by the interlocking branches of lesser giants, soaring more than 120 feet up and draped with vines, comprising a deep upper layer of foliage. Below a sparser layer is formed by younger trees of the same species and shorter growing trees. Only 10 per cent of the light from the sun reaches the forest floor. An undergrowth of seedlings and shade-loving plants and shrubs conspires with thronging tree trunks, some bolstered by giant buttressed roots, to curtail vision to a matter of feet. In places it is possible for a creature to pass at arm's length unnoticed. To outsiders the forest is claustrophobic and dark, filled with alarming sounds, alive with stinging and biting insects and home to dangerous animals, reptiles and plants. To its inhabitants it is thoroughly familiar, protective and benevolent.

88 ▪

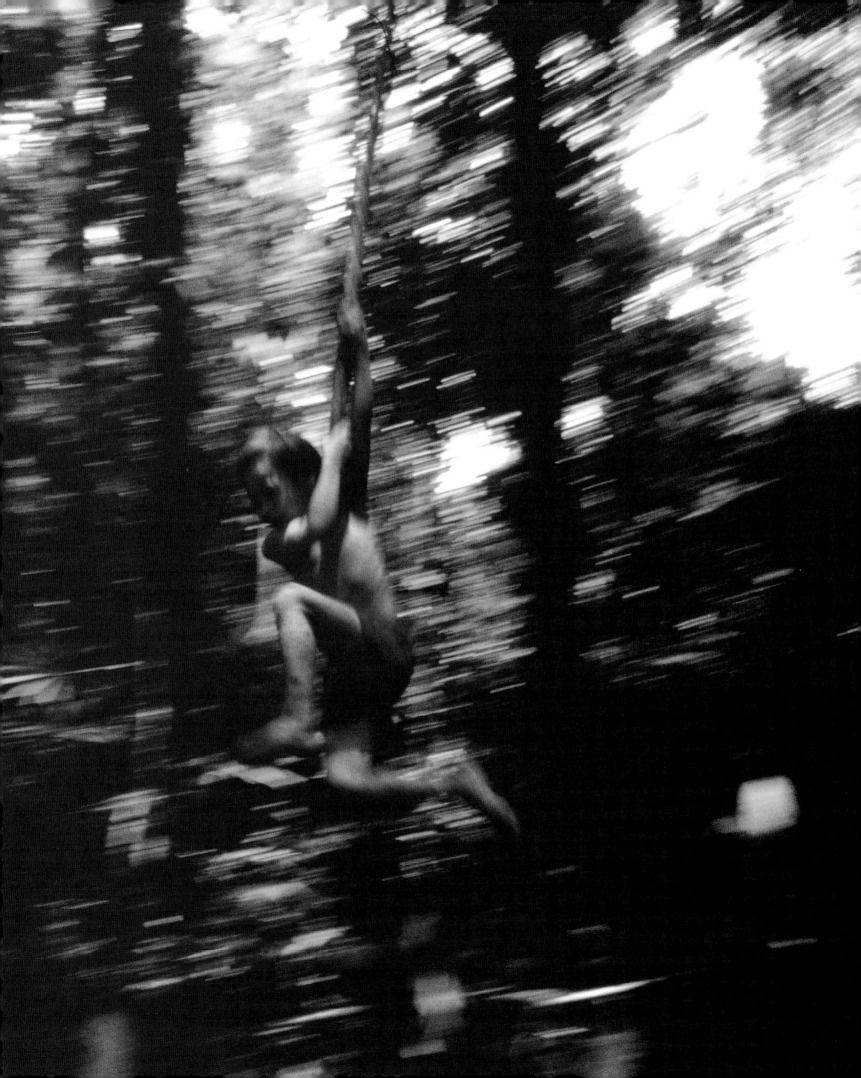

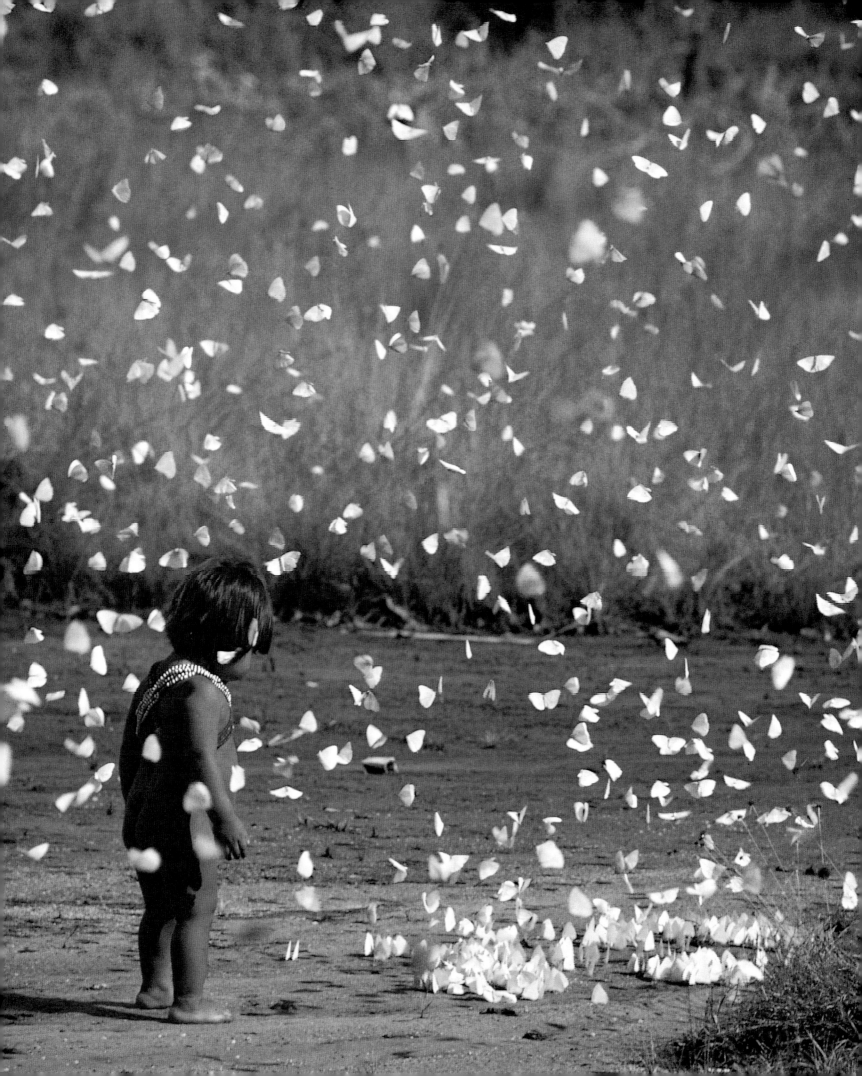

*C*ome spirit of speed,
Come Spiderhunter bird,
Send out wild boar easily seen,
Give them to me on the mountain,
Fulfill my wish, O kingfisher bird,
Give me boar when I go hunting.

Hunting prayer of Western Penan, Borneo

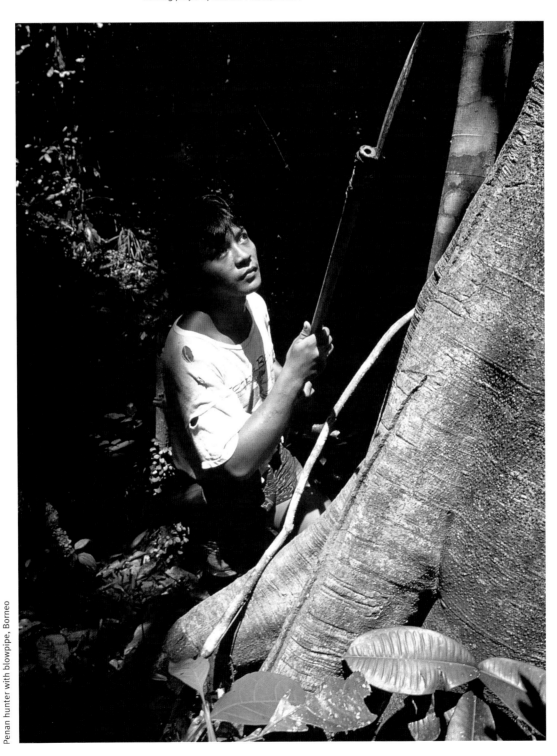

Ureue Wau Wau child with butteflies, Amazon, Brazil

Penan hunter with blowpipe, Borneo

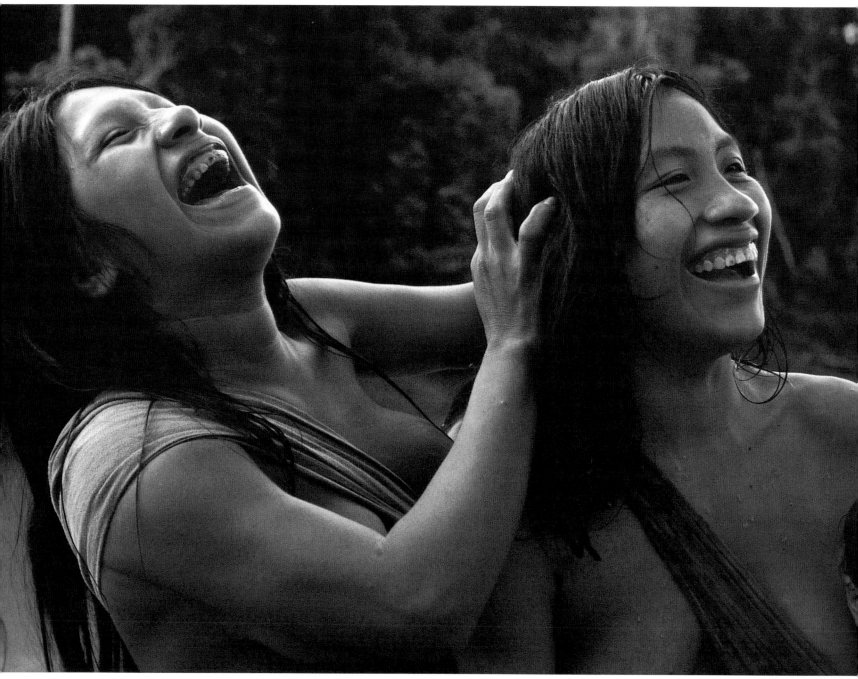

Auca indians, Ecuador

*W*hen we go out for food, we bring the monkeys food, like sago and fruits. And when some fruits are ripe, they are very happy, and they climb up to them, and they drop them down to us, and we eat them down here on the ground. And we're very content because it is they who climb up for them.

Lejeng Kusin, Penan, Borneo

Orang utan in Tanjung Puting Reserve, Borneo

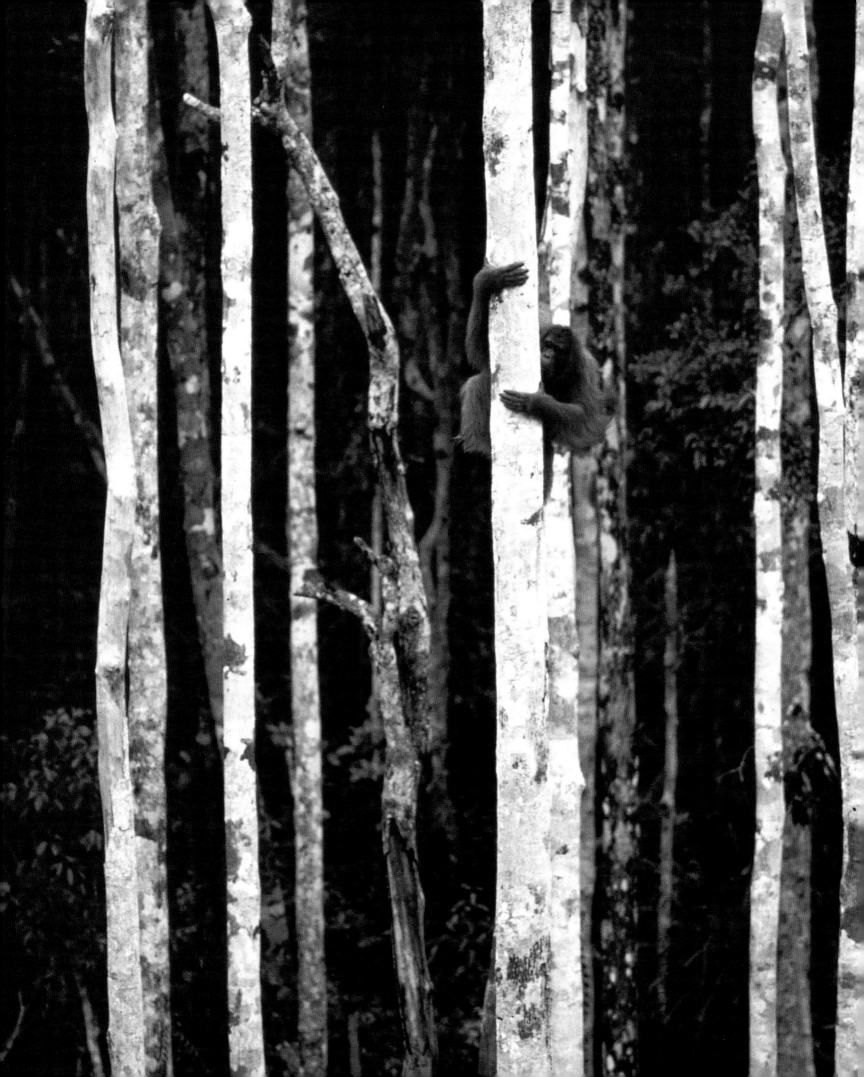

Red anatto seeds used for body paint

Kayapo indian woman with red dye, Brazil

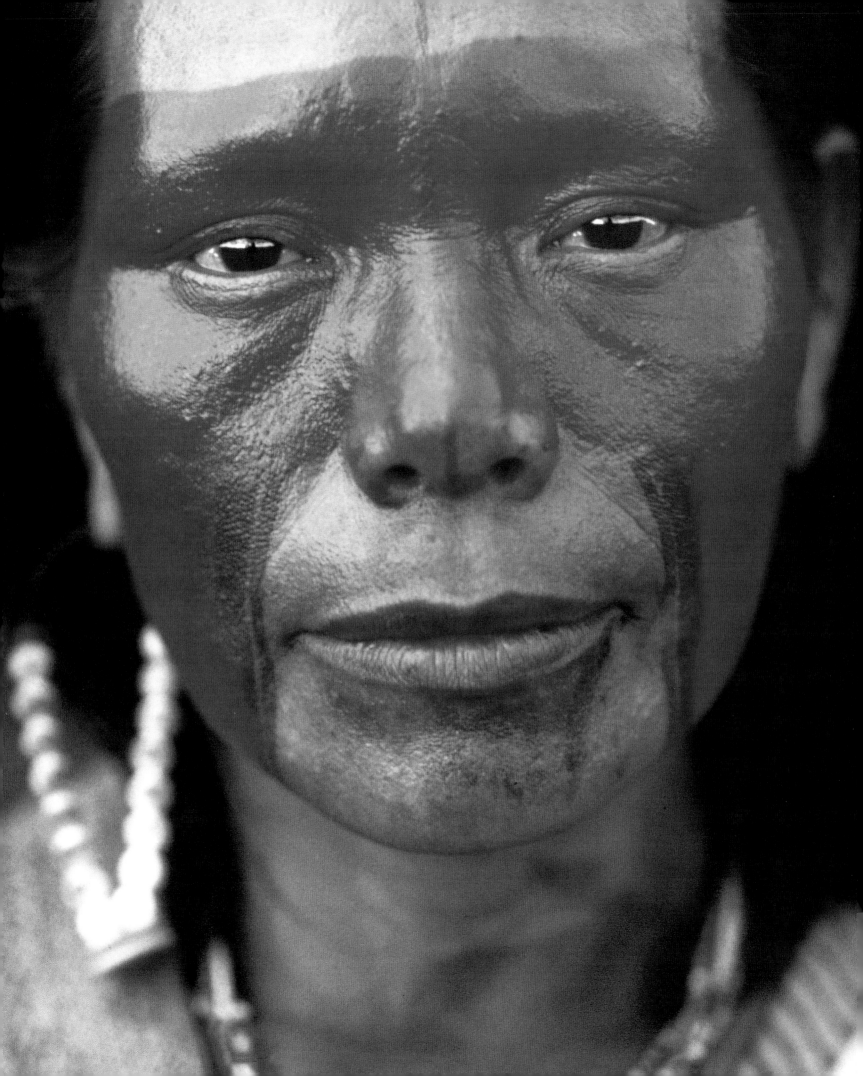

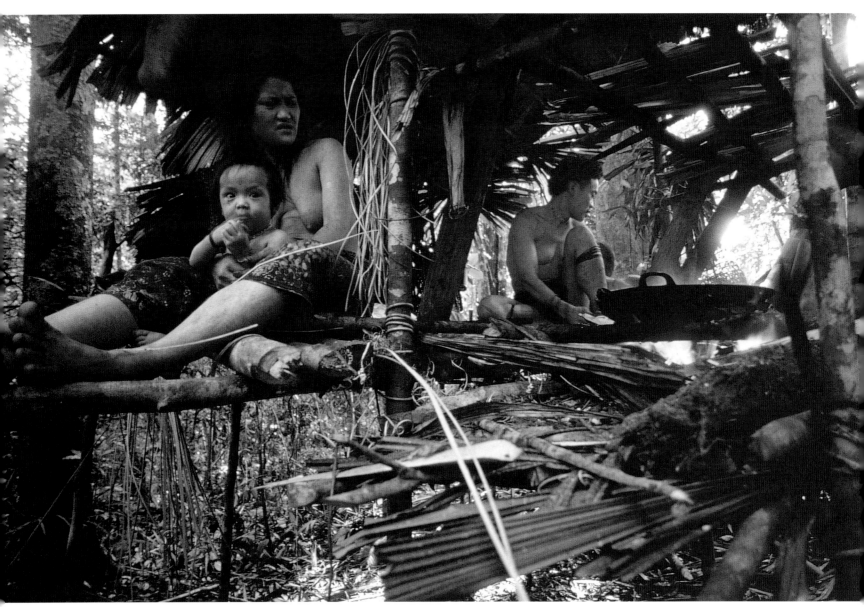

Our houses are made of trees, from rattan, from wooden poles, from leaves. And even though the posts that support them are slender, no thicker than my arm, we have bound them together using thin rattan.

Asik Nyelit, Penan, Borneo

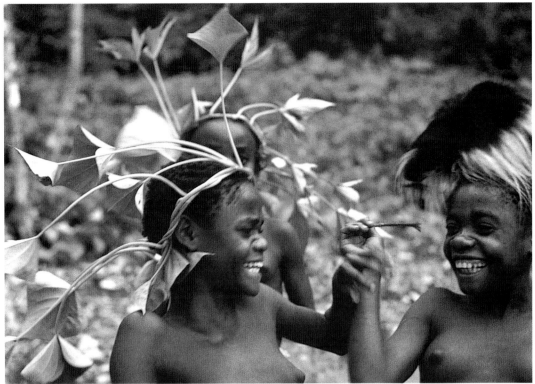

Mbuti girls with leaf and animal headgear, DR Congo

Penan people at home, Borneo

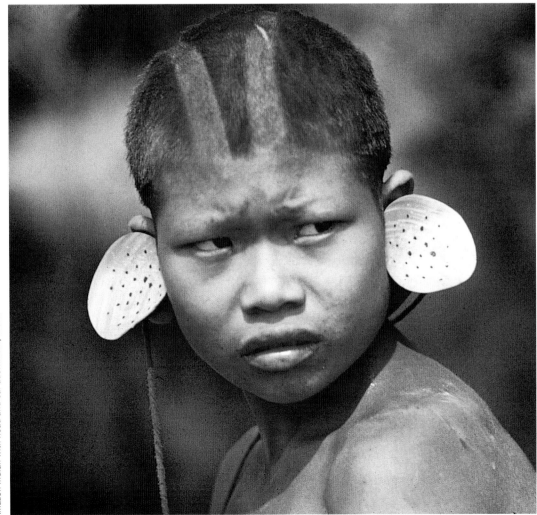

Amazon indian with head and ear adornment, Brazil

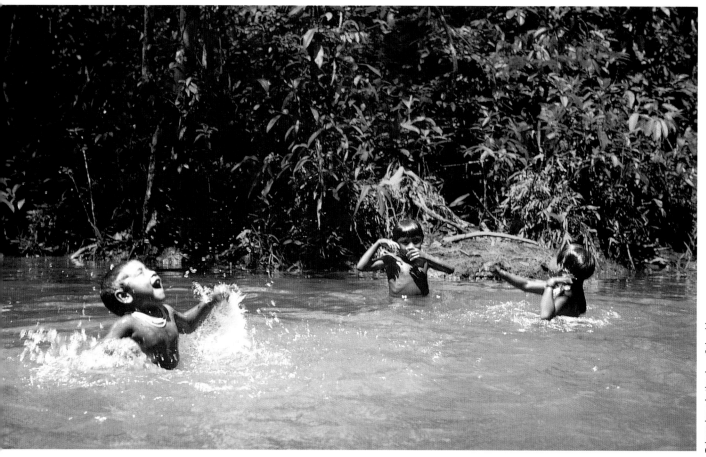

Tukano boys in the river, Colombia

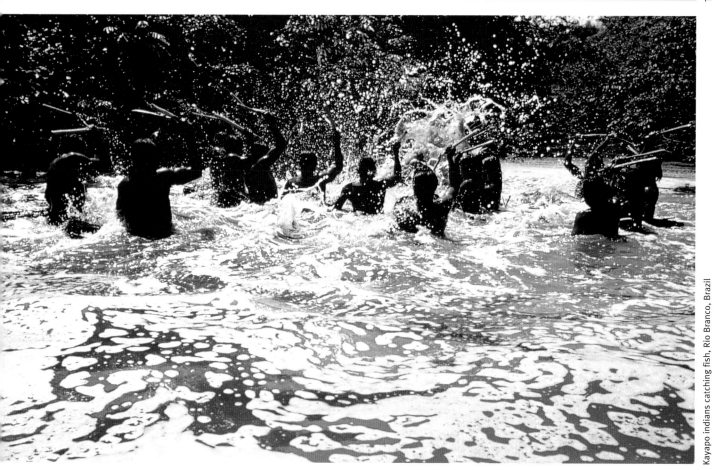

Kayapo indians catching fish, Rio Branco, Brazil

Auca boys playing in the mud, Ecuador

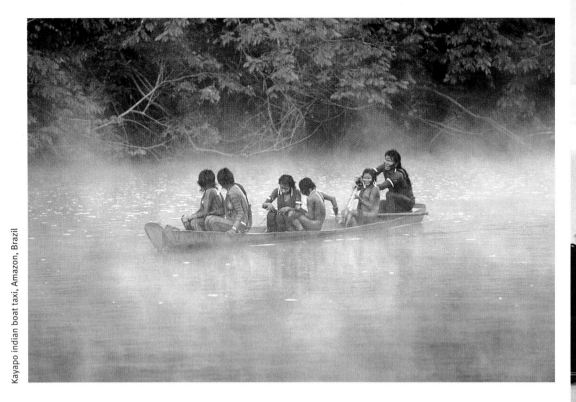

Kayapo indian boat taxi, Amazon, Brazil

***T**he rivers and trees are our
life. We are the protectors of
the rainforest.*

Moi, Huaorani, Ecuador

Lake in the Amazon, Brazil

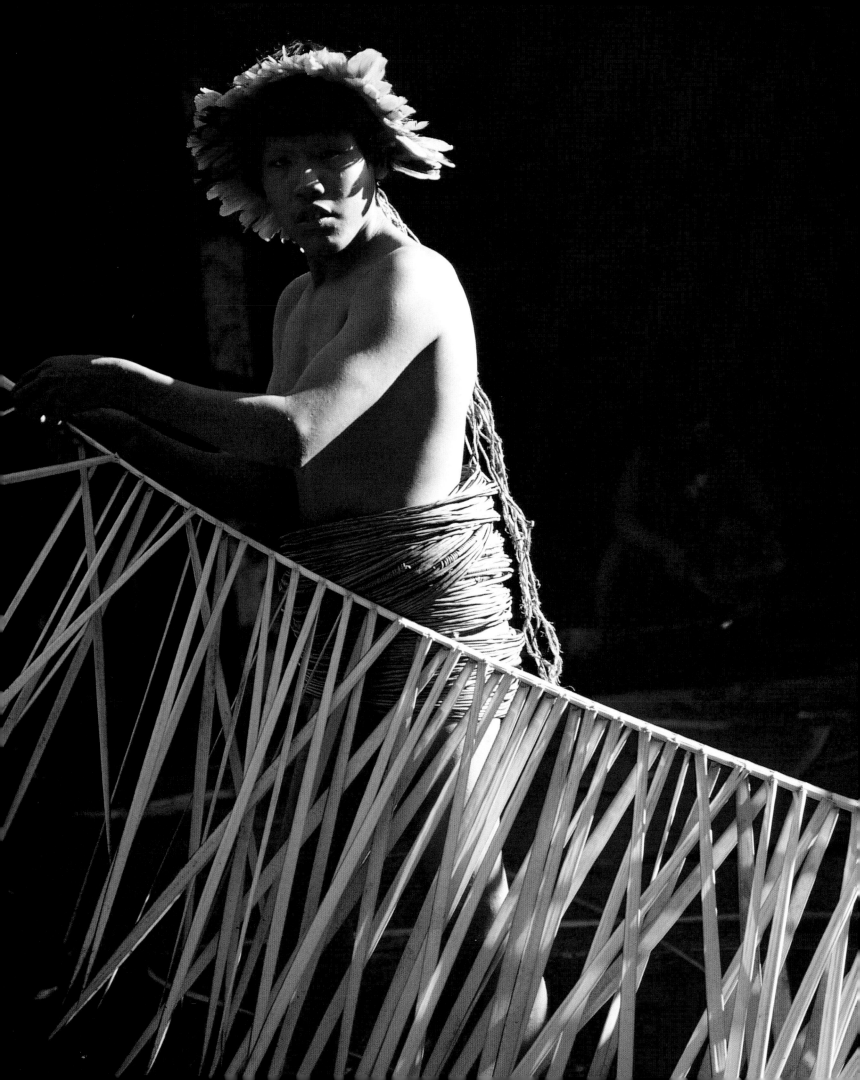

Feathers used for Tukano headdresses, Colombia

Feather decoration used by Barasana people, part of the Tukano group, Colombia

Building a house, Amazon, Brazil

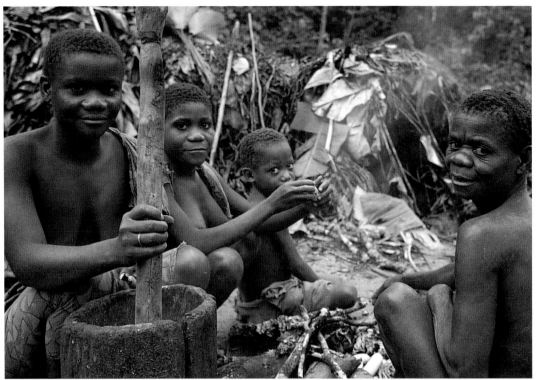

Mbuti women preparing vegetables, Ituri forest, D R Congo

Pygmy woman wearing a civet-skin hat, D R Congo

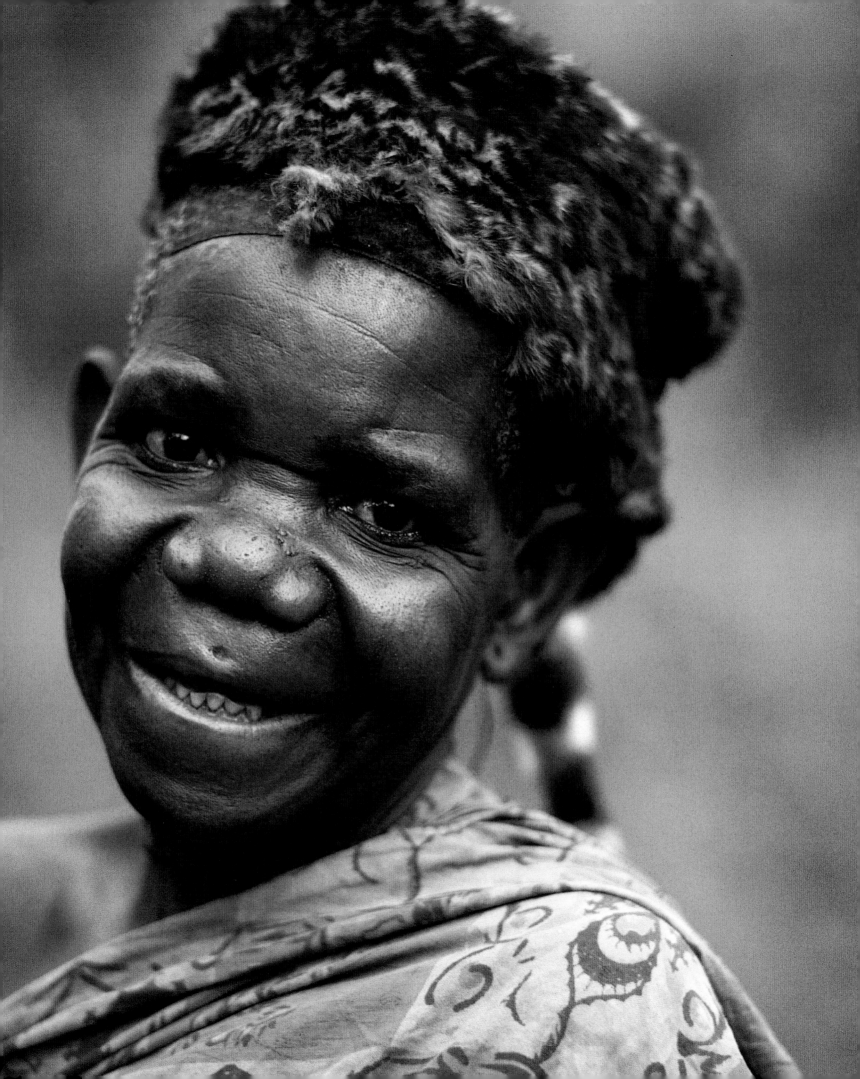

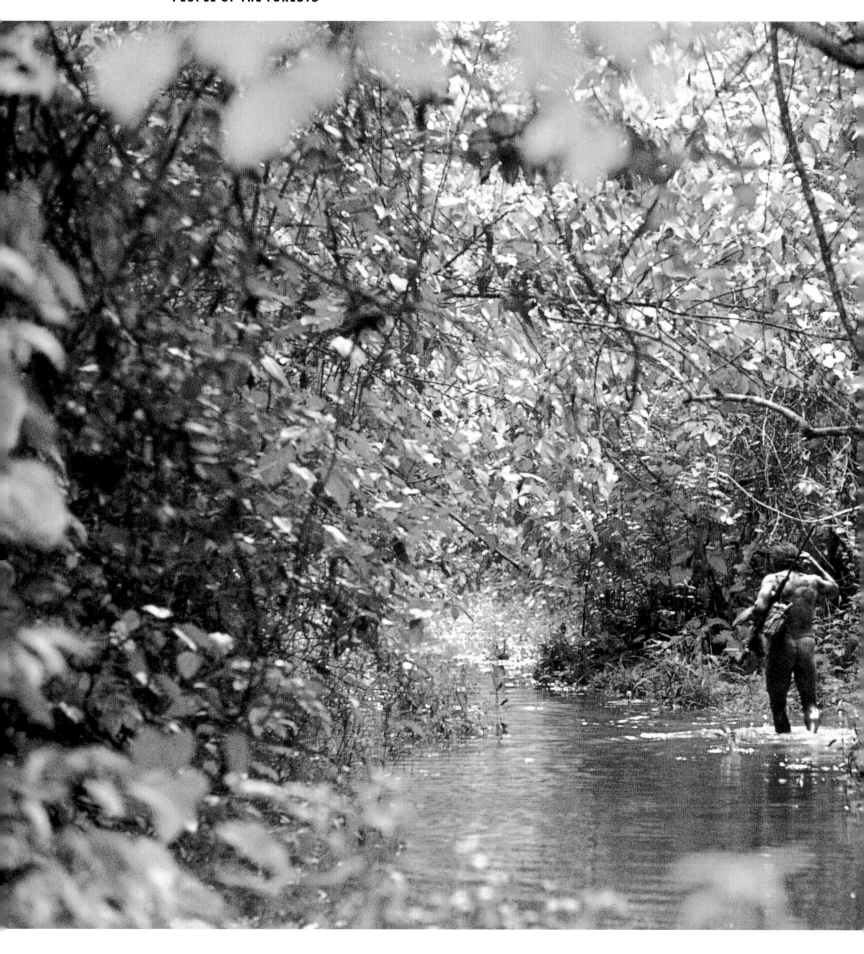

Mekranoti hunting, Amazon, Brazil

Yesterday I killed a deer,
Today I work with the skin.
I know how to hunt the pig.
My spears are hard,
They will not break.

Huaorani song, Ecuador

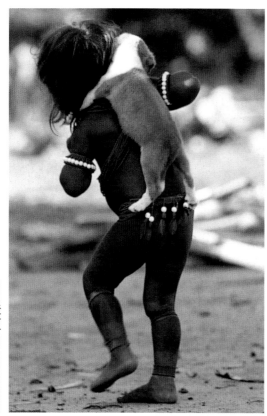

Mekranoti child with puppy, Brazil

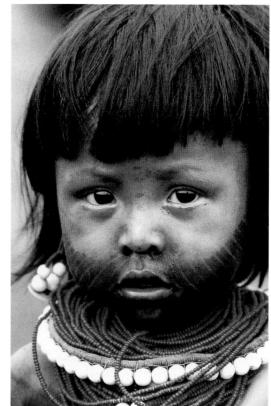

Mekranoti child wearing beads, Brazil

108 ■

Mekranoti people in the Amazon forest, Brazil

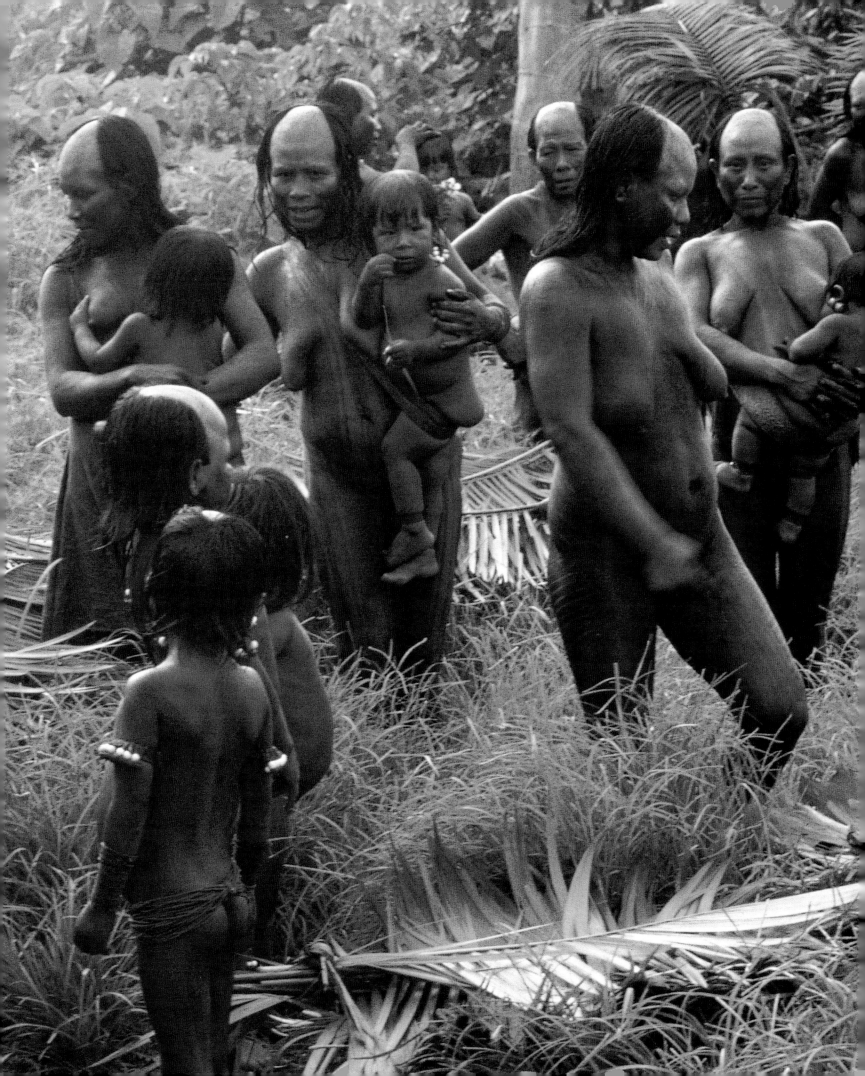

All around the snow lies, blanketing the earth and making the world strangely quiet. Sunlight glistens on the icy surface and the brightness stings the eyes. In time, accustomed to the glare, dark shapes in the distance begin to make sense. A line of straggly pine trees, their boughs weighed down with the latest snowfall. Occasionally, with the breeze, a flurry of flakes lifts off the branches and falls to earth with a gentle thud. Much further on, many miles beyond, the snowfields brook no plant life. That is the cold heart of the Arctic region. Icy seas, ice dashed away to reveal deep pools of deadly cold water. There, all is inky blue and white. But for nomadic peoples like the Sami in Norway, Inuit and Innu in North America and Greenland, the snowy worlds are their domain, providing food from bears, seals, fish and reindeer or caribou.

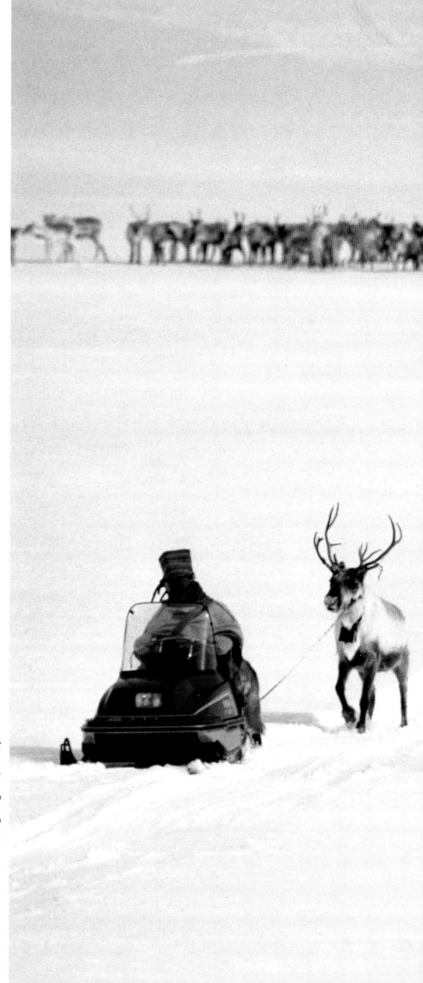

Sami herder with lead reindeer and migrating herd, Norway

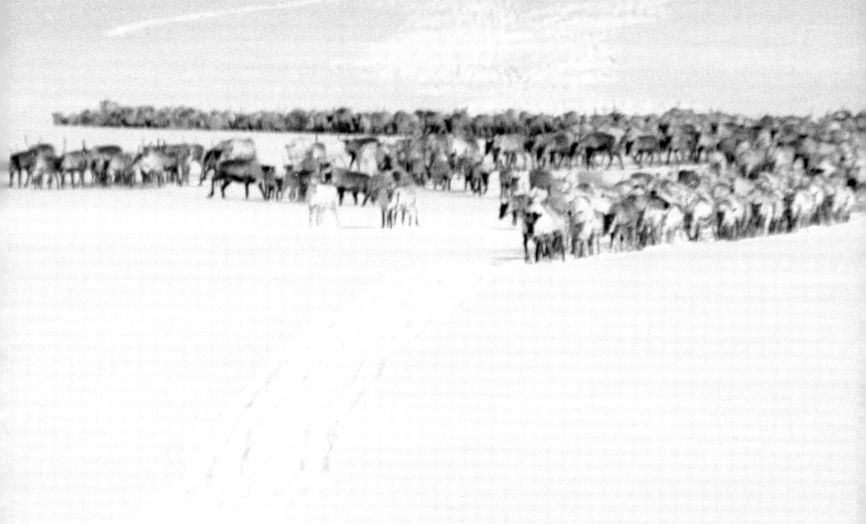

*T*he dogs sank into the snow, too tired to fight, and they buried their noses between their paws and let the snow-smoke drift over them, while our women sat in the shelter of our sleds and nursed the small children.

The Story of Comock the Eskimo [Inuit]

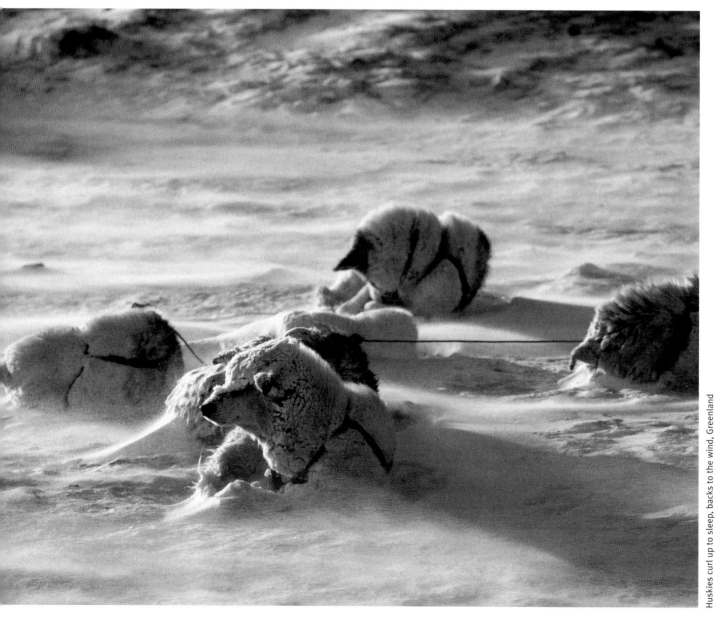

Huskies curl up to sleep, backs to the wind, Greenland

Baby of Evenki reindeer herders, Russia

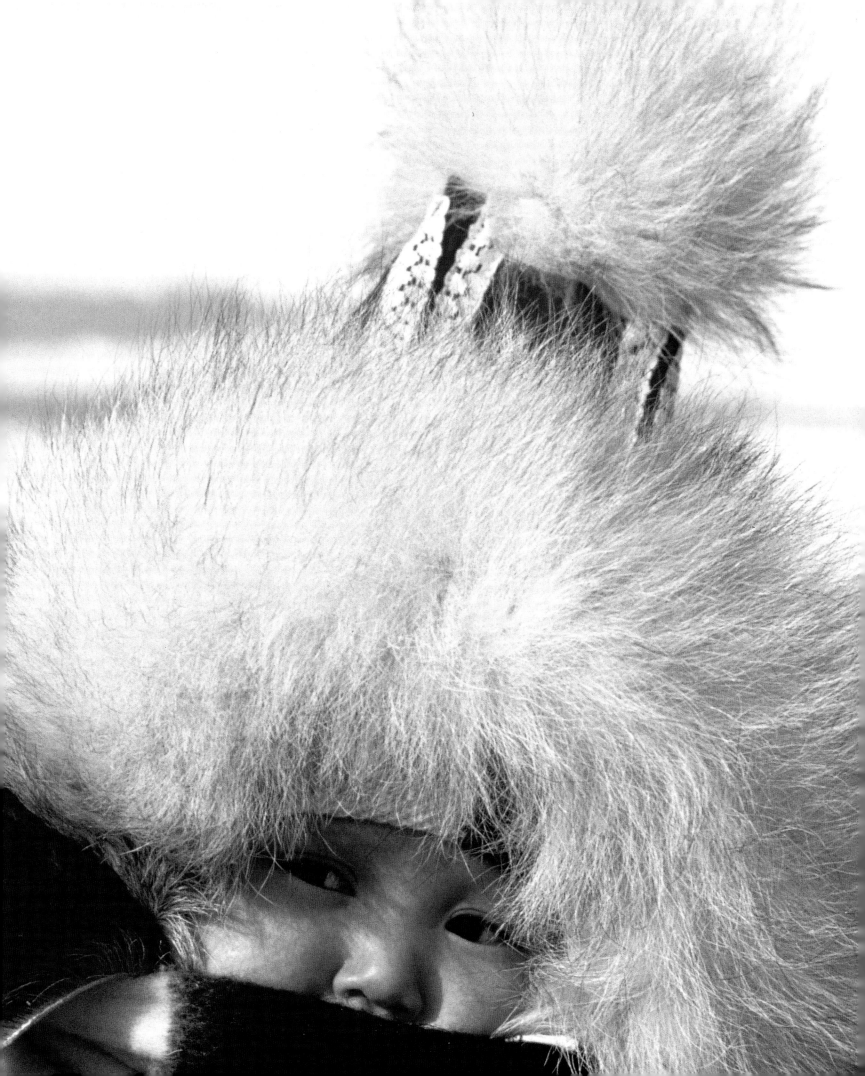

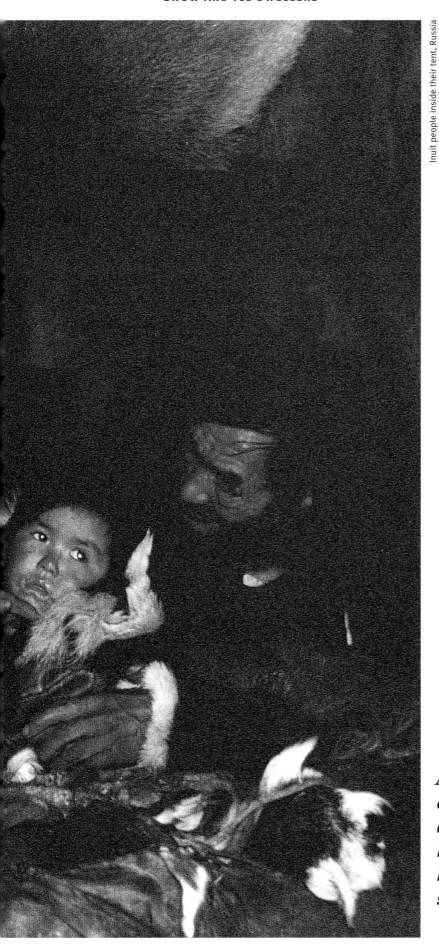

Inuit people inside their tent, Russia

An Innu hunter's prestige comes not from the wealth he accumulates but from what he gives away. When a hunter kills caribou or other game he shares with everyone else.

Daniel Ashini, Innu, Canada ■ 115

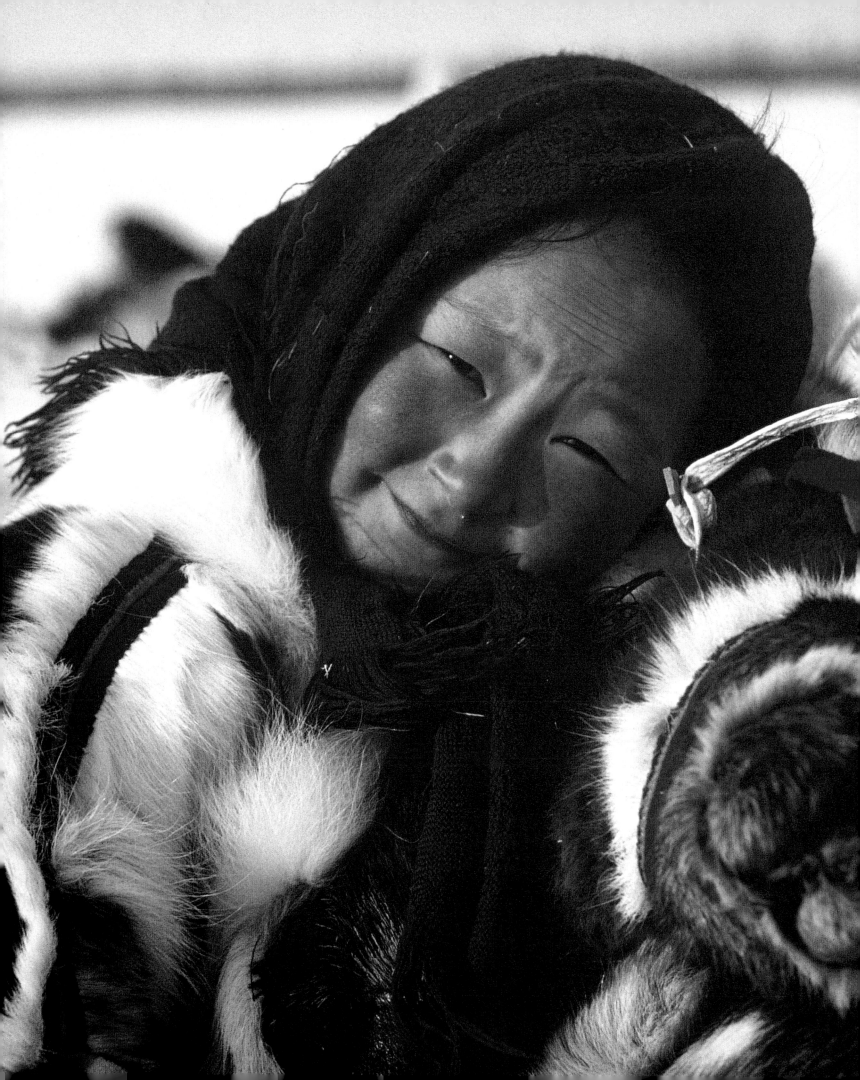

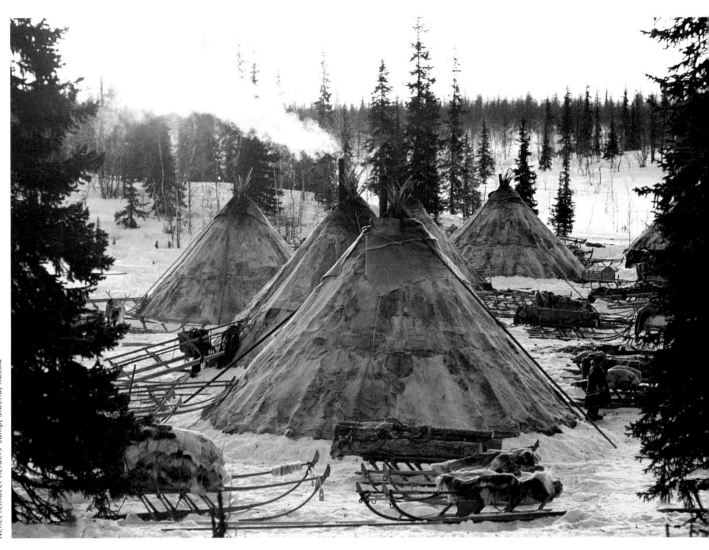

Nenet reindeer herders' camp, Siberia, Russia

Nenet woman on the migration, Siberia, Russia

A person is born with animals. He has to eat animals. That is why the animals and a person are just like one.

Inuit saying

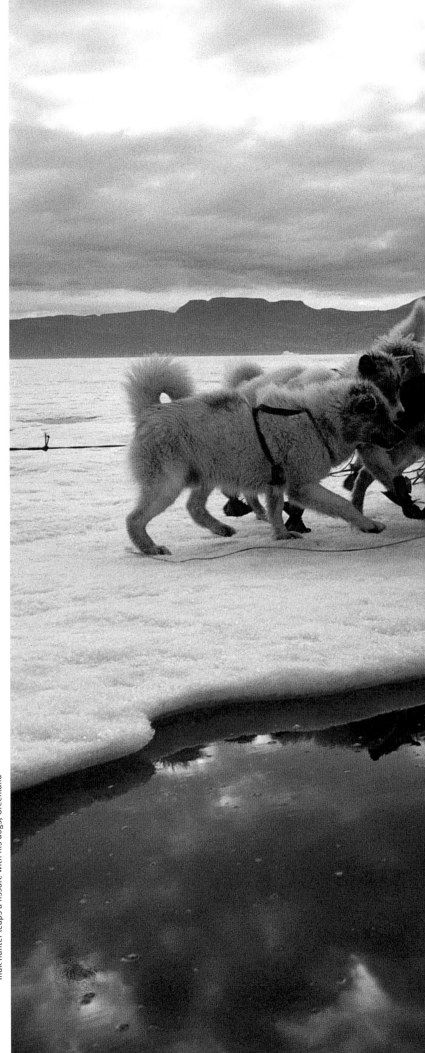

p120/121, The Northern Lights (Aurora Borealis) in Canada
Inuk hunter leaps a fissure with his dogs, Greenland

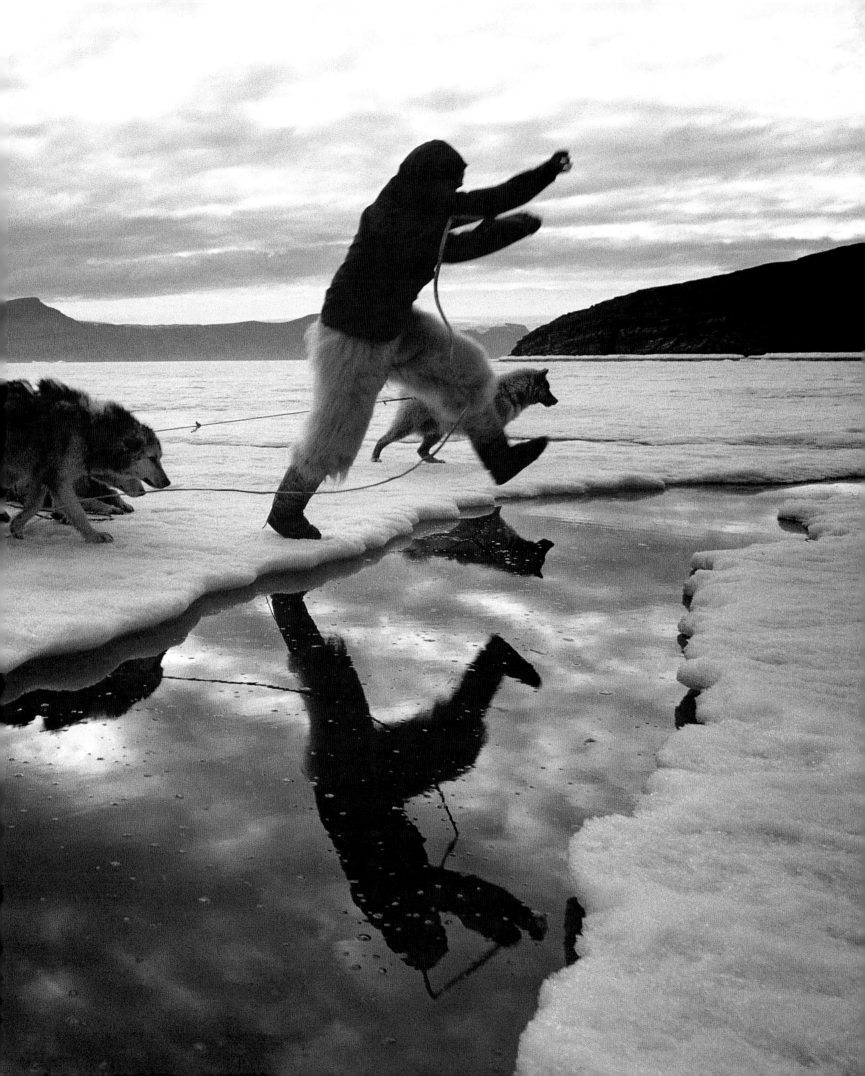

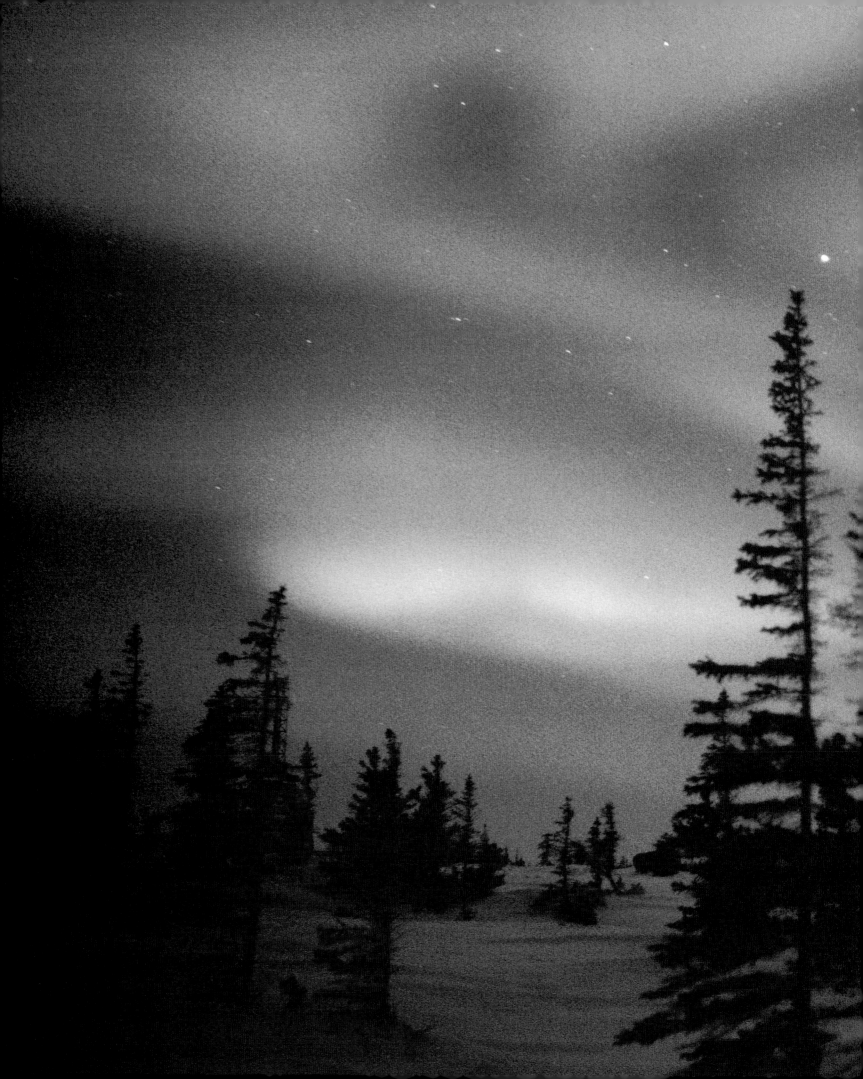

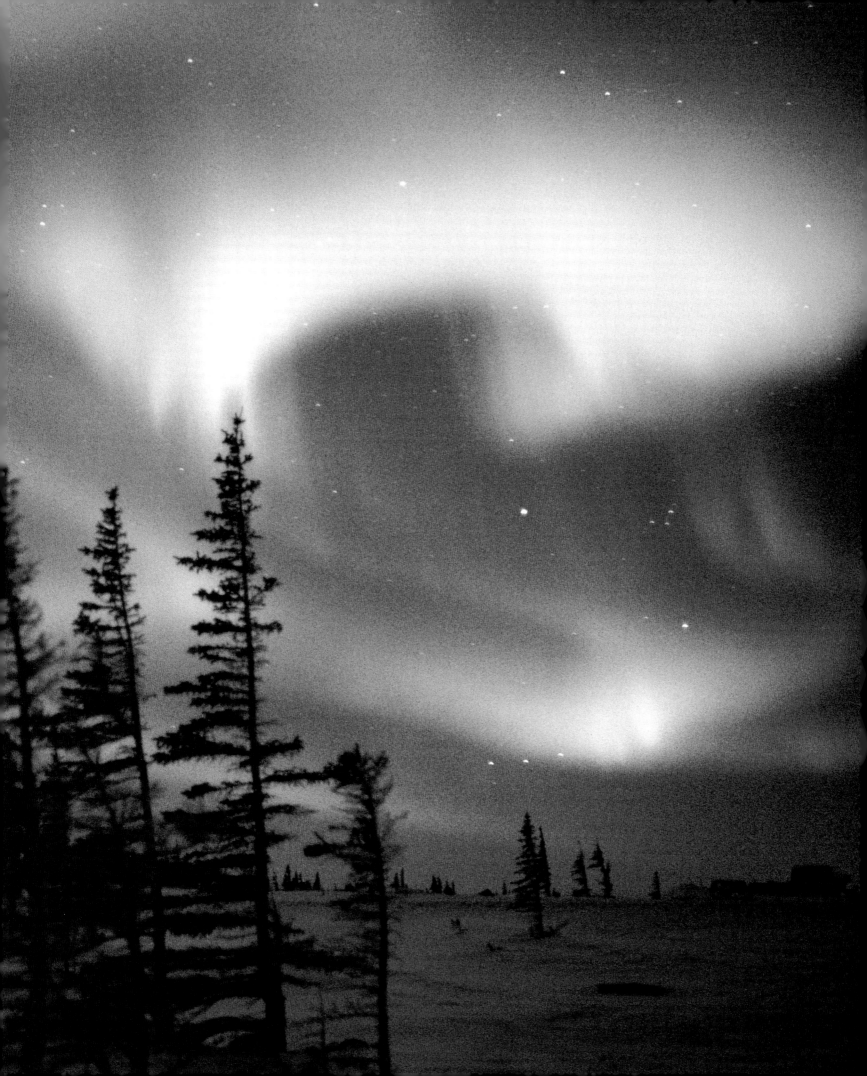

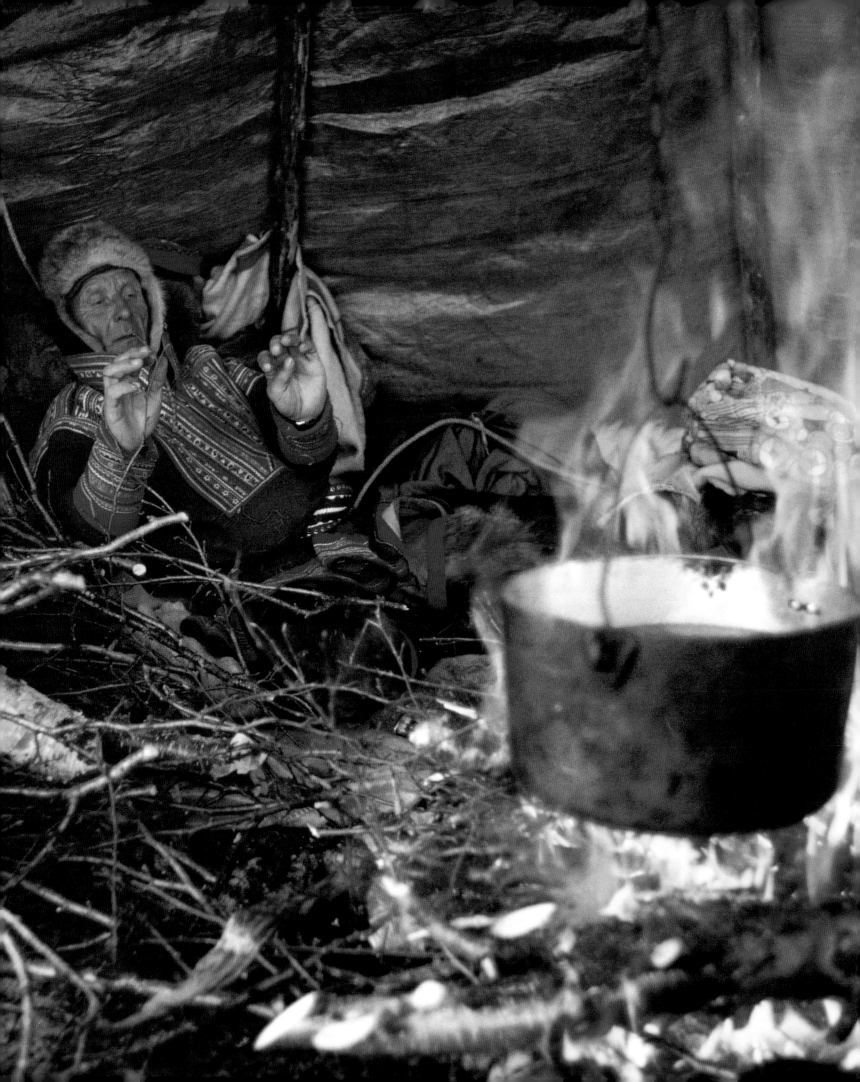

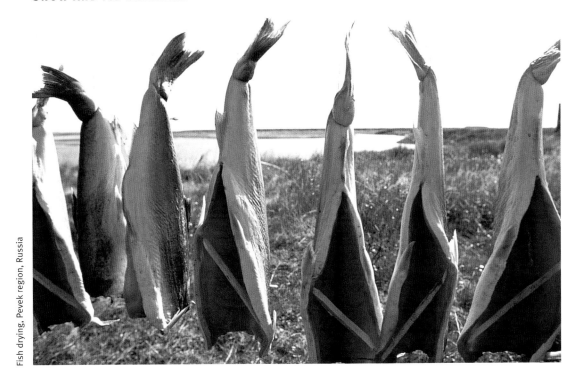

Fish drying, Pevek region, Russia

*M*igration with the reindeer has been an important factor in the development of Sami culture. The wandering life is a life of freedom. There are no chains binding us to the same place. New landscapes and new perspectives also liberate the mind and thoughts.

Nils-Aslak Valkeapaa, Sami, Norway

Sami herder warming himself during the spring migration, Finnmark, Norway

p124/125, An Inuit hunter pursues a pod of narwhals, Greenland

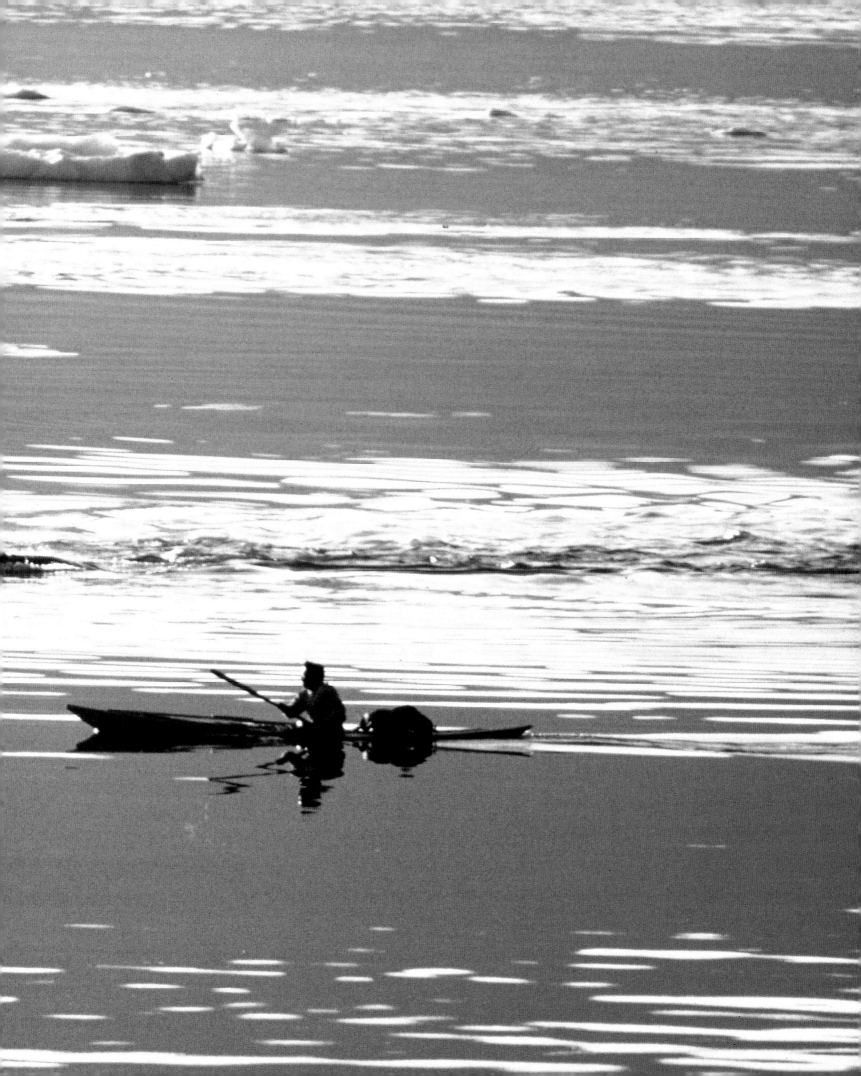

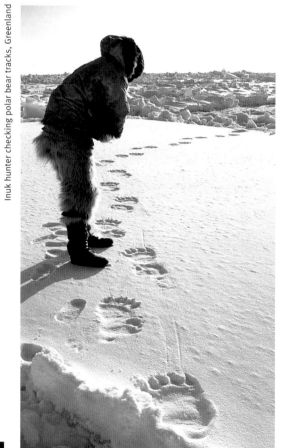

Inuk hunter checking polar bear tracks, Greenland

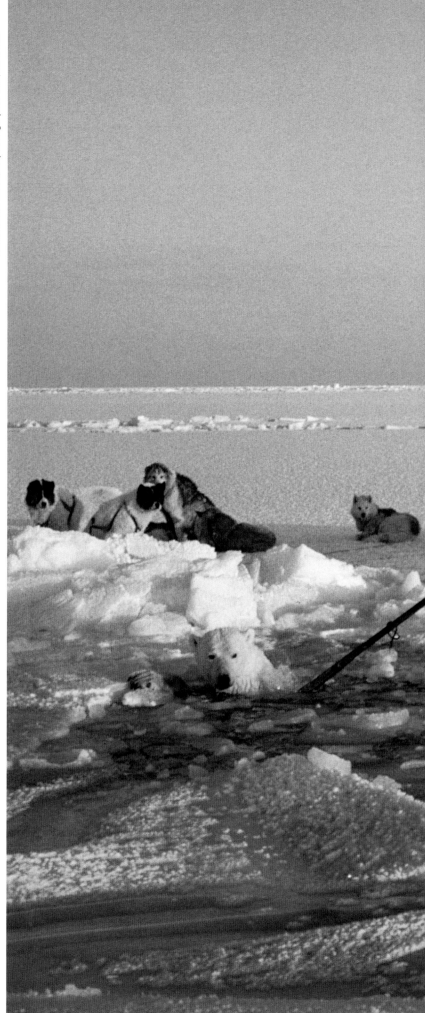

Ituko, an Inuk hunter, harpooning a polar bear, Greenland

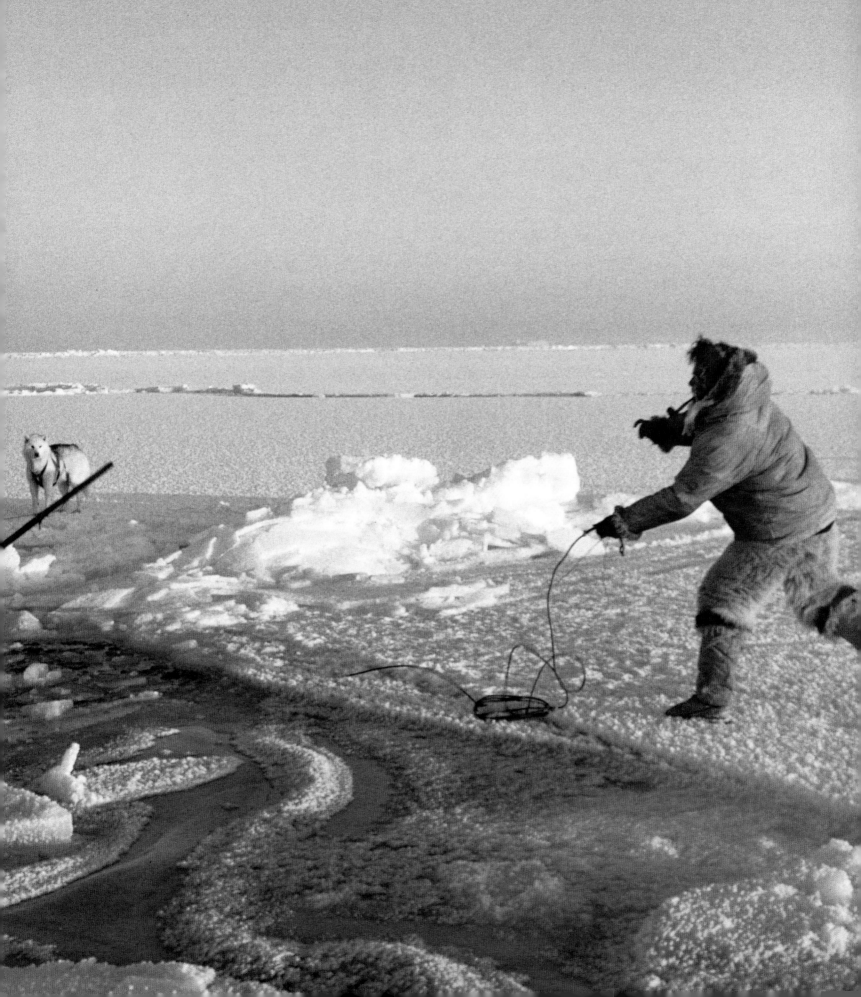

*D*ays passed, weeks passed: we were more and more cruelly tormented by hunger. Not one seal, not one hare, not one bird. On top of this, the weather worsened and grew colder; the wind gusted and snow fell.

Sakaaeunnguaq, Inuit, Greenland

p130/131, Nenet reindeer herd, Russia
Nenet herder with reindeer on migration, Russia

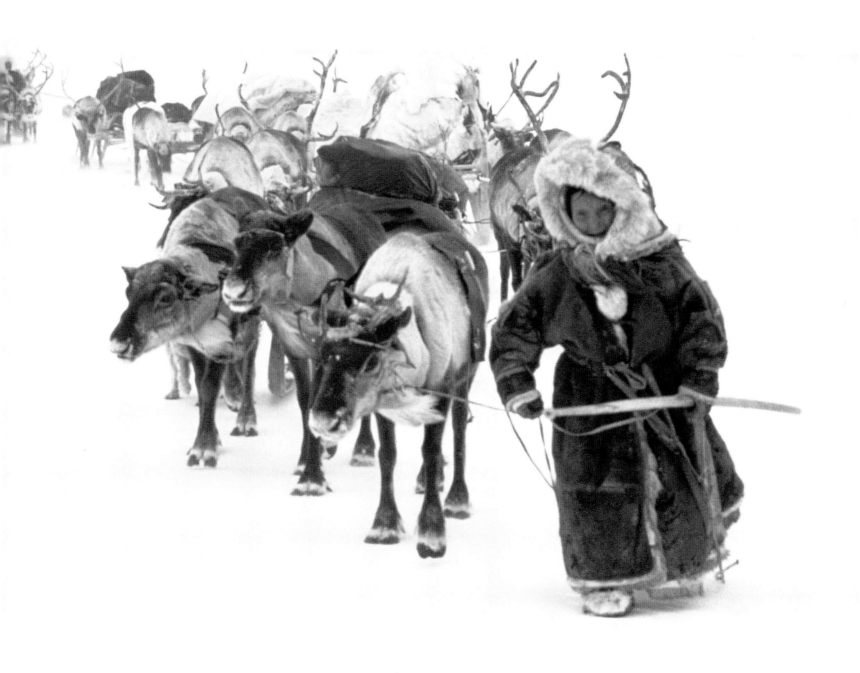

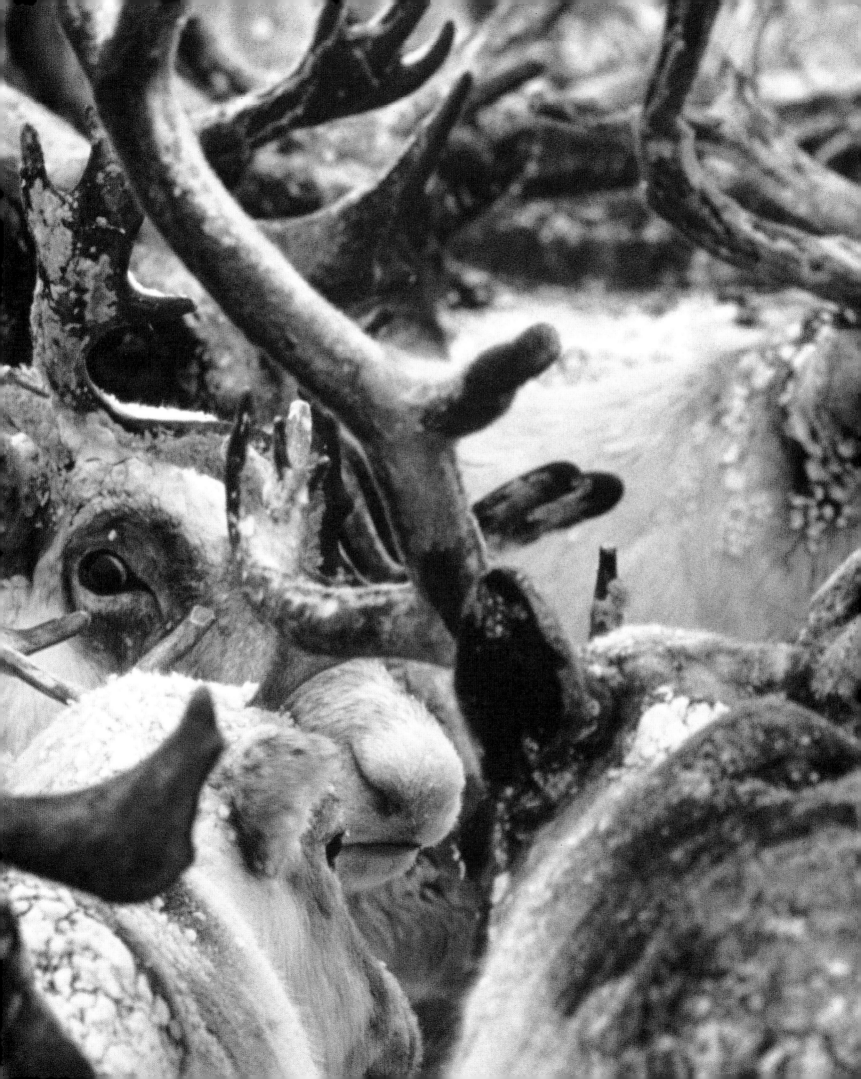

Palana, a Koryak reindeer herder, Siberia, Russia

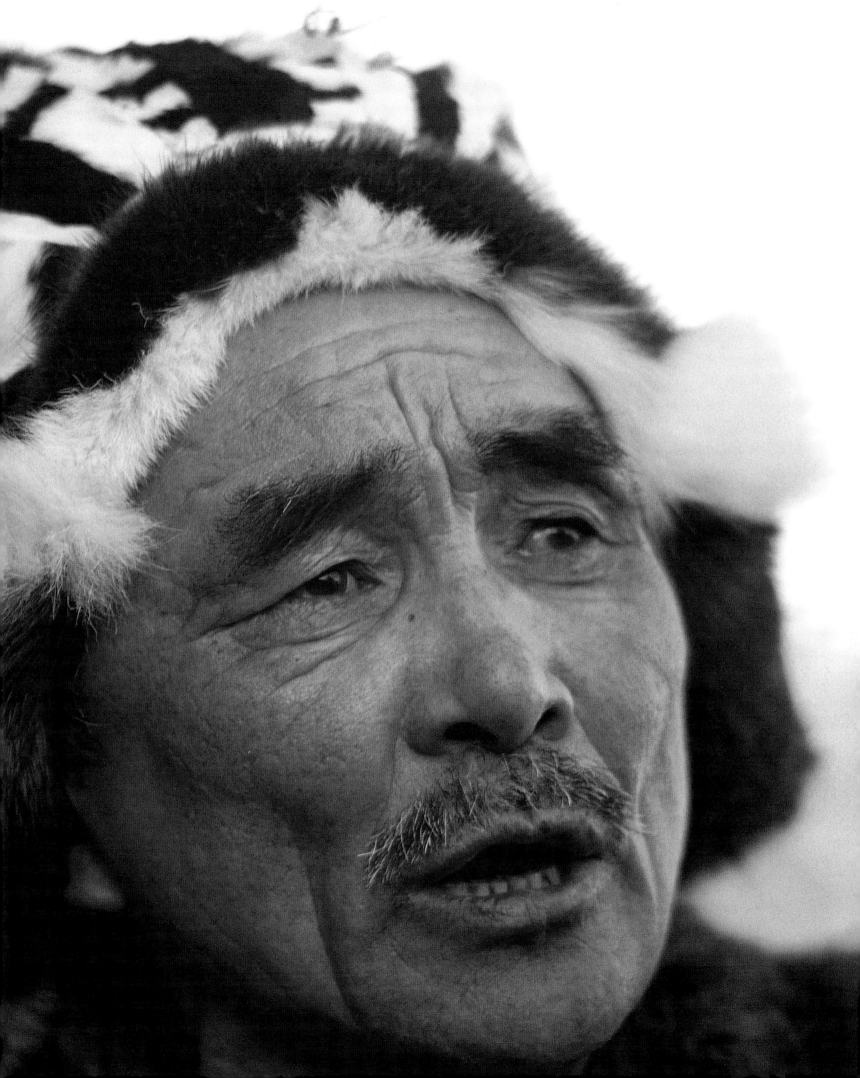

*W**e have to find the strength to make a place for ourselves in this world. Otherwise there will soon be no more of us. We will all be gone. And so will our memories. Only our paintings will remain behind to remind you of us.***

Mahongo, former nomad, southern Africa

Nomadic people have not been able to establish with most outsiders the kinds of relationships they experience within their communities. They often regard others who enter their territory as intruders. There have been episodes of great violence between Amazonian Indian groups and also between neighboring groups of pastoral people in Africa. But the greatest violence has resulted from collisions of interest between nomadic groups and the settled world. The decimation of nomadic people, such as North American Indians, Aboriginals in Australia and Bushmen/San in South Africa, and the appropriation of their territories in the process of colonization are well documented.

Nomadic groups and their environments continue to be threatened by the settled world's tireless quest for resources – timber, natural gas, oil, precious stones and minerals and land – and by pollution. Some 9 million hectares of the world's forests are being lost each year. In Borneo, as a result of commercial logging, the last nomads of southeast Asia live in dismal settlements of wooden shacks built of planks from the trees of their forests; fewer than 250 of the more than 7,000 Penan still live in the rainforest.

They have entered our area, they have invaded our rivers, they have made them dirty and muddy, they have trespassed on our forest paths. They never told us, 'Now we are going to demolish your sago, now we are going to destroy your rivers, your hills, your land, your home. Now we are going to obliterate your rattan, and all the other things you get from the forest. All the fruit trees. The place where you Penan live.' They acted without warning, straightway they destroyed everything.

Penan, Borneo

A similar picture is seen in South America, with the invasion by the oil companies:

The Huaorani want no more advancement of oil development, because the roads are the first step in the invasion of colonists. We do not want the contamination, the noise or the disruption of the oil companies. We will defend our territory against all invaders because we are the bravest people in the Amazon.

Statement by Huaorani people

In Alaska, the Aleut people who have survived on the Bering Sea for thousands of years lament the lack of scientific investigation into the high levels of pollution. From the mid-1970s there were rapid declines in sea lion, fur seal and seabird populations in the Bering and North Pacific.

Anecdotally, we hear about massive contaminant discharges into the Bering Sea from Russia. We know that the US military dumped mustard gas and similar lethal contaminants into the Bering Sea during World War II. The huge Bering Sea fishing fleets discharge tons of sewage and detergents into the sea daily with unknown consequences.

Larry Merculieff, Aleut, Alaska

Rusting oil drums polluting Nenet environment, Siberia, Russia.

Underpinning the cavalier treatment of nomadic peoples and their environments has been the assumption that they are remnants of an earlier stage of human development – savages or Stone-Age people – instead of people who have followed a different path. Their territories have been regarded as wildernesses to be tamed, belonging to nobody, before their appropriation by nation states. There has been no understanding or respect for the values which govern peoples' relationship with their territory.

In Canadian Northwest Coast societies, peoples' rights to ancestral territory is established, in their oral tradition, by their stories and songs. Hugh Brody tells us how in the 1980s Mary Johnson, 80-year-old chief of the Gitxsan people, sang part of her evidence to a court in British Columbia to establish her people's claim to their ancestral land. The judge was very reluctant to hear her sing. Others in the court were deeply moved. They understood how her song affirmed her group's rights. The judge dismissed their claim, ruling that oral evidence did not count. He also said that the applicants lacked 'the badges of civilization, had no written language, no horses or wheeled vehicles' and that aboriginal life in the territory was, at best, 'nasty, brutish, and short.' His judgment was later overturned.

Embarrassed to find that they have 'primitives' within their borders, numerous governments have worked determinedly to settle nomadic people, as have churches and religious movements wishing to convert them to a 'civilized' way of life.

However, new attitudes are emerging. Nomadic groups, supported by outsiders, are getting organized and demanding a say in decisions that affect them. Penan people for example have sustained a determined and courageous campaign of passive resistance in Sarawak, forming human roadblocks against the bulldozers destroying their forest. Addressing the General Assembly of the United Nations in 1992, Penan leader Anderson Mutang said:

The government says that it is bringing us progress and development. But the only development that we see is dusty logging roads and relocation camps. For us, their so-called progress means only starvation, dependence, helplessness, the destruction of our culture, and the demoralization of our people. The government says it is creating jobs for our people. But these jobs will disappear along with the forest. In ten years, the jobs will all be gone, and the forest that has sustained us for thousands of years will be gone with them.

Anderson Mutang, Penan, Borneo

Despite the strength of their campaign, the Penan have not yet been able to stop the logging.

In the snowy north of the world, Inuit people have formed a Circumpolar Conference (ICC), uniting indigenous people from Canada, Alaska, Greenland and Russia in promoting understanding of their culture and pressing for greater political and cultural self-determination.

In 1979, Greenland Inuit won regional Home Rule, providing a model for indigenous self-government for which there is no precedent. Canadian Inuit also won a major victory with the creation in 1999 of Nunavut ('Our land'), a vast separate territory in the Canadian eastern Arctic.

Aboriginal peoples' rights to reclaim their lands was restored in 1992 when the High Court of Australia handed down a decision overturning the colonial concept of *terra nullius* ('the land belonged to no one' when the colonists arrived). The judgment holds that native title must be recognized where any Crown Land remains and where indigenous people, still observing laws and customs, had continuing association with that land.

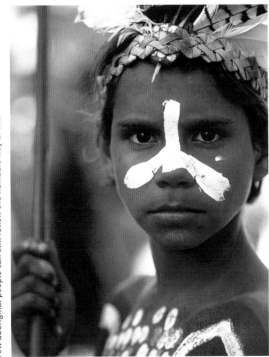

Few aboriginal people can still follow the nomadic way of life.

As well as gaining legal rights, some nomadic people are gaining the recognition that they are wise about the world's harsh places. People who live by hunting and gathering are superb botanists and naturalists with intimate knowledge of their environments. Some observers think that the knowledge of indigenous people has the potential to transform the economies of regions and even entire nations. The claim does not seem too exaggerated when one reflects on the commercial values of 'Swiss' chocolate, 'Italian' tomatoes, 'European' potatoes, 'Hawaiian' pineapples – all first domesticated by Indians in Central and South America.

There is also a growing belief that the settled world may have much to learn from hunter-gatherers about the principle of sharing and respect for the environment, as noted in *The National Geographic*:

▌It is a way of being altogether different from the one in which human beings have separated themselves from their environment and seek to tame and conquer it.

Perhaps the greatest legacy of the indigenous peoples will be their contribution to a dialogue between these two world views such that folk wisdom may temper and guide the inevitable development processes that today ride roughshod over much of the Earth. ▌

Hope of what may be learned from dialogue and collaboration with nomadic people is tempered by two fears. One is that if they share their knowledge with people who do not understand the value of sharing they may well be the losers as they have been in the past. The other is that, as environments are destroyed, nomadic groups and cultures are displaced and even their languages disappear, the opportunity for fruitful dialogue is slipping away.

The whole world must come and see how the Huaorani live well. We live with the spirit of the jaguar. We do not want to be civilized by your missionaries or killed by your oil companies. You cannot put a price on our land. Must the jaguar die so that you can have more contamination and television?

There are so many cars in your world. In ten years your world will be pure metal. Did your god do this? More people, more cars, more petroleum, more chaos. But in here are the Huaorani, all alone in the middle of the world.

Moi, Huaorani, Ecuador

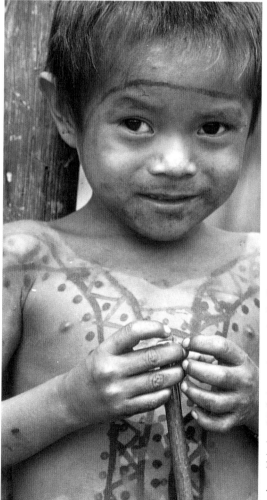

Arara boy with body paint of a jaguar, Amazon, Brazil. Oil companies, loggers and new settlers are squeezing out nomadic people.

AUSTRALIAN ABORIGINALS

Originally nomadic hunter-gatherers. Today the majority live in towns and cities. Torres Strait Islanders, another indigenous group, were traditionally cultivators and sea-farers.

Territory: Australia. The few still living a nomadic existence are in Northern Territory, the north of Western Australia, and North Queensland. Australian Aboriginals occupied Western Australia for more than 40,000 years before the arrival of European colonists. Their many languages and dialects are not related to any other. At one time there may have been 500 language groups.

Population: 200,000; one per cent of the Australian population.

Food: Traditionally a wide range of game, reptiles, grubs, roots and vegetation.

Religion: Animist; the Dreamtime is the creation story. Some are Christian.

BAKA

Pygmy hunter-gatherers. Few if any pursue their traditional way of life.

Territory: South Cameroon rainforest.

Population: Not known. Total pygmy population of Central Africa estimated at 100,000.

Food: Traditionally game, honey, fruits, nuts.

Religion: Animist.

BEDOUIN

Arabic-speaking nomadic pastoral people. Bedouin traditionally herded camels but have increasingly switched to herding sheep and goats. Many have become sedentary while others resist attempts to settle them and are modernising and adapting to preserve their commitment to herding.

Territory: Northern Arabian semi-desert of Arabia, Oman, Iraq, Syria and Jordan.

Population: Egypt 1 million; Syria 925,000; Saudi Arabia 551,000; Jordan 256,000; Algeria 2.7 million; Libya 780,000; Mauritania 315,000; Morocco 376,000.

Food: Meat, vegetables, rice, cheese.

Religion: Sunni Muslim.

FULANI

Some groups are nomadic pastoralists who herd mainly cattle. Others are semi-sedentary and sedentary.

Territory: The Sahel belt from Senegal to Sudan.
Population: 10 million overall.

Food: Dairy produce and grain from the markets of agricultural villages.

Religion: Many are Muslim converts.

GABRA

Nomadic camel-herders. They also herd sheep and goats. Most still pursue traditional way of life.

Territory: Arid lowland plains to the east of Lake Turkana, northern Kenya. A smaller group known as Gabra Miigo lives in Ethiopia but is not a focus of this book.

Population: 35,726 (1989).

Food: Milk, blood of their camels, meat of their sheep and goats, maize/corn traded.

Religion: Gabra believe in Waaqa, a supreme being on which nature and life depend.

HUAORANI

Tropical rainforest hunter-gathering people. Most now live within a protectorate.

Territory: Amazonian forest in Ecuador.

Population: 1,500.

Food: Fruit, honey, game – monkeys, white-lipped peccaries (wild pig), birds, some fish.

Religion: Huaorani people believe in a creator and an afterlife. Those in the protectorate have converted to Christianity.

INUIT

Hunters and gatherers traditionally but now settled.

Territory: Alaska and Greenland.

Population: 32,000 in Alaska; 45,000 in Greenland.

Food: Traditionally, fish, whale blubber and meat, seal, walrus, caribou and smaller game, berries.

Religion: Animist.

MBUTI

Pygmy hunter-gatherers. Some Mbuti have been pressured to leave the forest and large areas of their territory have been opened up to gold prospectors.

Territory: Central part of the Ituri rainforest, Democratic Republic of Congo.

Population: Not known. Total pygmy population of Central Africa estimated at 100,000.

Foods: Game, honey, fruits, nuts, caterpillars, termites, fungi, traded grain.

Religion: Animist.

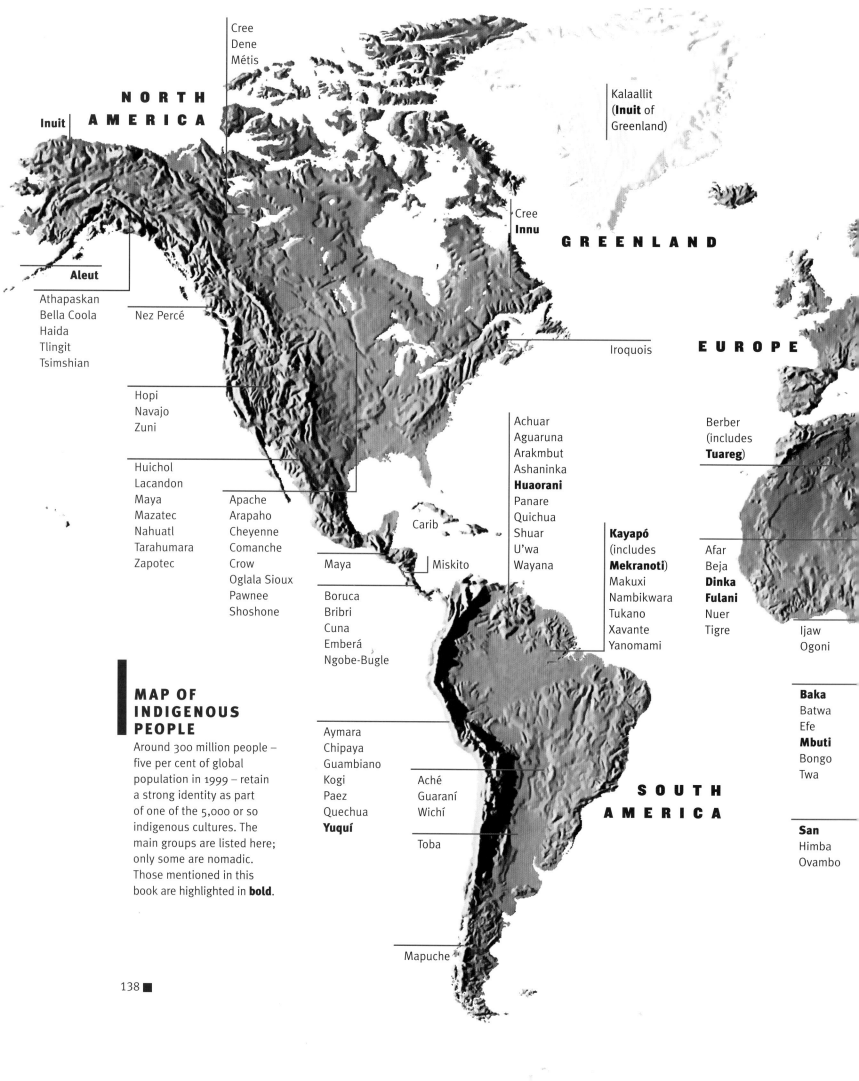

Cree
Dene
Métis

NORTH AMERICA

Inuit

Aleut

Athapaskan
Bella Coola
Haida
Tlingit
Tsimshian

Nez Percé

Hopi
Navajo
Zuni

Huichol
Lacandon
Maya
Mazatec
Nahuatl
Tarahumara
Zapotec

Apache
Arapaho
Cheyenne
Comanche
Crow
Oglala Sioux
Pawnee
Shoshone

Maya

Carib

Miskito

Boruca
Bribri
Cuna
Emberá
Ngobe-Bugle

MAP OF INDIGENOUS PEOPLE

Around 300 million people – five per cent of global population in 1999 – retain a strong identity as part of one of the 5,000 or so indigenous cultures. The main groups are listed here; only some are nomadic. Those mentioned in this book are highlighted in **bold**.

Aymara
Chipaya
Guambiano
Kogi
Paez
Quechua
Yuquí

Aché
Guaraní
Wichí

Toba

Mapuche

Kalaallit (**Inuit** of Greenland)

Cree
Innu

GREENLAND

Iroquois

EUROPE

Achuar
Aguaruna
Arakmbut
Ashaninka
Huaorani
Panare
Quichua
Shuar
U'wa
Wayana

Kayapó (includes **Mekranoti**)
Makuxi
Nambikwara
Tukano
Xavante
Yanomami

Berber (includes **Tuareg**)

Afar
Beja
Dinka
Fulani
Nuer
Tigre

Ijaw
Ogoni

Baka
Batwa
Efe
Mbuti
Bongo
Twa

SOUTH AMERICA

San
Himba
Ovambo

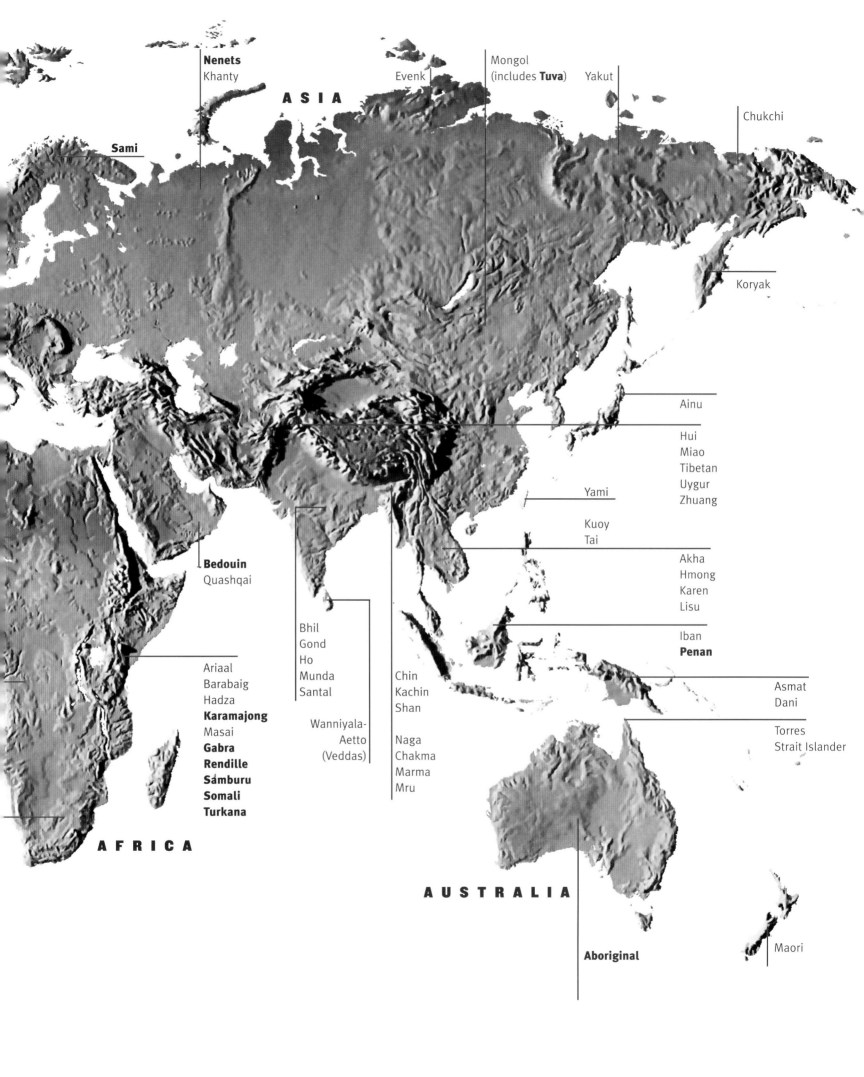

Nenets
Khanty

Evenk

Mongol
(includes **Tuva**)

Yakut

ASIA

Chukchi

Sami

Koryak

Ainu

Hui
Miao
Tibetan
Uygur
Zhuang

Yami

Kuoy
Tai

Bedouin
Quashqai

Akha
Hmong
Karen
Lisu

Iban
Penan

Bhil
Gond
Ho
Munda
Santal

Asmat
Dani

Ariaal
Barabaig
Hadza
Karamajong
Masai
Gabra
Rendille
Samburu
Somali
Turkana

Chin
Kachin
Shan

Torres
Strait Islander

Wanniyala-
Aetto
(Veddas)

Naga
Chakma
Marma
Mru

AFRICA

AUSTRALIA

Aboriginal

Maori

MEKRANOTI

Sub-group of Kayapo Indians. Semi-nomadic hunter-gatherers who also practice some agriculture. After strong resistance to the outside influences the younger generation is turning away from the traditional way of life.
Territory: Rainforest of the Amazon River Basin in central Brazil. They live in villages along the upper tributaries of the Xingu River.
Population: There are about 600 Mekranoti among 4,000 Kayapo (1993).
Food: Wide range of game, forest fruits and cultivated bananas, sweet potato, manioc/cassava.
Religion: Animist.

NENETS

Hunting and foraging people, turned caribou pastoralists. Forced under the Soviets to settle on collectivized farms, most lost their traditional skills and lifestyles except some 343 households who still live with their herds on the tundra and taiga (coniferous forest).
Territory: North-western Russia between the White Sea and the Taymyr Peninsula, with the Arctic Ocean to the north. They move from northern tundra pastures in summer to the sub-Arctic taiga forests in winter.
Population: 34,000.
Food: Mainly derived from their herds, with some game and fish.
Religion: Animist.

PENAN

Nomadic hunter-gathering people; very few now live a traditional way of life, due to the destruction of their forest.
Territory: Equatorial rainforest, Sarawak, a Malaysian state in the northwest of Borneo.
Population: More than 7,000; however fewer than 250 still live as hunter-gatherers.
Food: Traditionally sago, a starch extracted from sago palm, forest fruits and roots, wild game.
Religion: Animist.

SAMI

Former hunters, turned reindeer herders. No longer nomadic.
Territory: Northern Norway, Sweden, Finland and the Russian Kola Peninsula.
Population: About 68,000, 40,000 of whom are in Norway.
Religion: Majority are Lutheran.

SAN (BUSHMEN)

Nomadic hunters who also forage and gather. Very few still pursue a nomadic existence.
Territory: Parts of the Kalahari, Botswana, Namibia, Angola and a very few in South Africa where they were virtually exterminated.
Population: 90,500; a third in Namibia; 45,000 in Botswana. There are different language groups of San, including the !Kung and G/wi.
Food: Game, caterpillars, termites, roots and vegetation, especially Mongongo nuts.
Religion: San believe in a creator of the world and a lesser supernatural power, who causes death and illness, and spirits.

RENDILLE

Rendille pastoral people who live to the southeast of Lake Turkana in East Africa. Their region is dry with barely seven inches of rainfall a year. In the harsh terrain they herd camels.
Populaton: 22,000.
Food: Mainly blood and milk from their camels.

SAMBURU

Living in the area north of Mount Kenya, the Samburu are cattle-herders who also keep sheep and goats. Cattle wealth deeply affects the social structure as cattle are chattels, property, money, and the measure of male pride and dignity.
Population: 75,000.
Food: Meat, milk and blood from their cattle.

SOMALIS

Several different groups in Somalia, East Africa, mainly herding camels but also cattle, sheep and goats.
Food: Milk from their animals; meat on special occasions; rice, corn, dates, edible roots.

TUAREG

Related to the Berbers and Bedouin people, Tuaregs are nomadic pastoralists living in the northern desert regions of Africa, in Algeria, Mali and Niger. Their herds include camels, cattle, sheep and goats and they are dependent on oasis water for their livestock.
Population: About 1 million.
Food: Meat and milk from their animals.

TURKANA

Nilotic pastoral people living west and south of Lake Turkana, Kenya. Formerly part of the Karamojong cluster of tribes of northern Uganda. Once mainly cattle herders, in the harsh environment of north western Kenya they have also taken to herding camels, many of which they raided from the Gabra.

Population: 340,000.

Food: Blood and milk of their animals.

Religion: The Turkana believe in a God (Kuj) who is associated with the sky and is the creator of all things.

TUVA

Tuvans are descended from a mixture of Mongol, Turkic and European backgrounds. They lead a semi-nomadic way of life, living in portable wool yurts. They migrate three to four times a year, following their natural hunting and fishing cycles. Aside from the Tibetans, Tuvans are the only other ethnic group who have the ability to throat-sing. Throat-singers produce a surreal sound which involves two separate lines of music, both melody and harmony, being sung by a single person.

Territory: southern Siberia (Russia) and northern Mongolia.

Population: The main group numbered 64,000 in 1982.

Food: Süttüg shai (milky tea) and khoitpak (white curds floating in fermented milky water); meat; and araka-fermented cow or yak milk.

Religion: Buddhist, influenced by Tibetan Lamaism.

YUQUÍ

Probably less than 150 people, some still living as nomad foragers in the Bolivian rainforest in Cochabamba region near the Chimoré river. A group has settled at the Chimoré mission station. They may be part of a Guaraní migration into Bolivia from Paraguay, or Sirionó. They refer to themselves as Biá, 'people'.

Food: Palm hearts, tubers and fruits, honey, meat such as tapir and peccaries (wild pig), monkeys, sloths, deer and birds.

Religion: Animist. The Yuquí universe is perceived as consisting of both the living and the dead. The living are confined to their world while the dead may move at will. The world is filled with spirits, mostly of their own dead, who can enter animals or take other forms.

I am trying to save the knowledge that the forests and this planet are alive, to give it back to you who have lost the understanding.

Paulinho Paiakan, Kayapo, Brazil

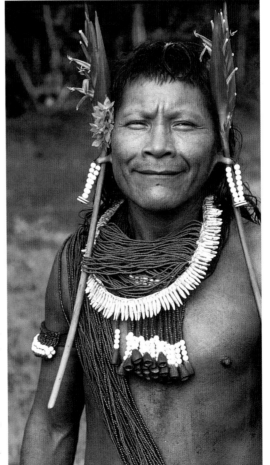

Kayapo medicine man, Amazon, Brazil. Even he is powerless against the forces of globalisation which are speeding the demise of his peoples' way of life.

BIBLIOGRAPHY

Amin, Mohamed, *Cradle of Mankind*, Chatto and Windus, 1981.

Anderson, B et al, *Subsistence Traditional Eskimo Life in the Latter Twentieth Century*. Arctic Circle – http://arctic circle.uconn.edu/HistoryCulture/ – Kuuvafmuit.

Australian Aborigines History and Culture Research Project.
http: www.aaa.com.au/hrh/aborigine/

Baxter P T W and Richard Hogg, Introduction to "Property, Poverty, and People: Changing Rights" in *Property and Problems of Pastoral Development*, 1990.

Beach, Hugh, "The Saami of Lapland", in *Polar Peoples*, Minority Rights Group, 1994.

Bird, Rose, Deborah, *Dingo Makes Us Human*, Cambridge University Press, 2000.

Brain, Robert, *Into the Primitive Environment*, Prentice Hall, 1972.

Briggs, Jean L, *Never in Anger*, Harvard, 1972.

Bringle, Mary, *Modern Eskimos*, Franklin Watts Ltd, 1974.

Brody, Hugh, *The Other Side Of Eden*, Faber and Faber, 2000.

Carpenter, Edmund, *The Story of Comock the Eskimo*, Fawcett Premier, 1972

Chatty, Dawn, *From Camel to Truck*. Vantage Press, 1986.

Chatty, Dawn, *Mobile Pastoralists*, Columbia University Press, 1996.

Chatwin, Bruce, *The Songlines*, Jonathan Cape, 1987.

Coles, Robert, *Eskimos, Chicanos, Indians: Children in Crisis*, Little Brown & Co, 1997.

Creery Ian, "The Inuit of Canada" in *Polar Peoples*, Minority Rights Group, 1993.

Dahlberg, F, *Woman the Gatherer*, Yale University Press, 1981.

Davis, Wade, *Shadows in the Sun*, Broadway Books, 1998.

Davis, Wade, et al, *Penan: Nomads of the Dawn*, Pomegranate Artbooks, 1995.

Dirie, Waris and Miller, Catherine, *Desert Flower*, Virago, 1998.

Foster, Warren, *Toonkoo and Ngaardi*, Copyright © Australian Museum, 1999.

Gowdy, John, "Hunter-gatherers and the mythology of the market", *Cambridge Encyclopaedia of Hunter-gatherers*, 1999.

Harney, William E, *Content to Lie in the Sun*, Robert Hale Ltd, 1958.

Kane, J, *Savages*, Pan, 1995.

Leakey, R, *The Making of Mankind*, Michael Joseph Ltd, 1981.

Lee, Richard and Daly, Richard, Eds, *Cambridge Encyclopaedia of Hunter-gatherers*, 1999.

Lewis, Ioan et al, *The Atlas of Mankind*, Mitchell Beazley, 1982.

Library of Nations, *Arabian Peninsula*, Time-Life Books.

Lienhardt, Godfrey, *Divinity and Experience*, Oxford University Press, 1961.

Malaurie, Jean, *Last Kings of Thule*, Jonathan Cape, 1982.

Man, John, *Jungle Nomads of Ecuador*, Time-Life Books, 1982.

Mantaigne, Fen, "Nenets: Surviving on the Siberian Tundra", *National Geographic*, March Issue 1998.

Marshall, Thomas Elizabeth, *Warrior Herdsmen*, Robert Hale Ltd, 1958.

Merculieff, Larry, *One Alaska Native's Perspective on Marine Contamination*, Greenpeace, 1996.

Mowat, Farley, *People of the Deer*, Michael Joseph, 1952.

Nuttall, Mark, "Greenland: Emergence of an Inuit Homeland" in *Polar Peoples*, Minority Rights Group, 1993.

BIBLIOGRAPHY

Pattel-Gray Anne, *Through Aboriginal Eyes*, WCC Publications, Geneva, 1991.

Rival, Laura, "Blowpipes and spears", in *Nature and Society*, Eds P Descola and G Pallson, Routledge, 1996.

Rival, Laura, "Prey at the Centre" in *Lilies of the Field: Marginal people who live for the moment*, Ed. Sophie Day et al, Westview Press, 1999.

Shostak, Marjorie, *Nisa: The Life and Words of a !Kung Woman,* Earthscan Publications Ltd, 1990.

Stearman, Allyn Maclean, *Yuquí Forest Nomads in a Changing World*, Holt, Rinehart and Winston, 1989.

Survival International, *Hunters and bombers*, 1998.

Survival International, *Hunters facing change*, 1998.

Tablino, Paul, *The Gabra: Camel Nomads of Northern Kenya*, Paulines Publications Africa, Limuru, Kenya, 1999.

Tchinag, Galsan, *In the Land of the Angry Winds*, Verlag im Waldgut, Frauenfeld, 1998.

The Australian Museum, Sydney. Website: http://www.austmus.gov.au

Turnbull, Colin, *Wayward Servants*, Eyre and Spottiswoode, 1965.

Turnbull, Colin, *The Forest People*, Pimlico Press, 1993.

Verswijver, Gustaaf, *Mekranoti: people of the Amazon*, Prestel, New York, 1996.

Wallace, Phil and Noel, *Children of the Desert*, Thomas Nelson & Sons Ltd, 1968.

Watson, Stephen, *Return of the Moon*, Carrefour Press, Cape Town, 1991.

Werner, Dennis, *Amazon Journey*, Simon and Schuster, 1984.

Wilder, Edna, *Once upon an Eskimo time*, Alaska Northwest Books, 1987.

PHOTO CREDITS